SURVEILLANCE
Means *Security!*
REMIXED WAR PROPAGANDA

SURVEILLANCE
Means *Security!*
REMIXED WAR PROPAGANDA

by MICAH IAN WRIGHT

Foreword by J. R. Norton

7

SEVEN STORIES PRESS
New York □ London □ Melbourne □ Toronto

In Canada:
Publishers Group Canada, 250A Carlton Street, Toronto, ON M5A 2L1

In the UK:
Turnaround Publisher Services Ltd., Unit 3, Olympia Trading Estate, Coburg
Road, Wood Green, London N22 6TZ

In Australia:
Palgrave Macmillan, 627 Chapel Street, South Yarra VIC 3141

ISBN-10: 1-58322-741-5
ISBN-13: 978-1-58322-741-1

College professors may order examination copies of
Seven Stories Press titles free for a six-month trial period.
To order, visit www.sevenstories.com/textbook, or fax on
school letterhead to (212) 226-1411.

9 8 7 6 5 4 3 2 1

Printed in Canada.

"The mortal realities of war must be impressed vividly on every citizen. . . .] War means death. It means suffering and sorrow. The men in the service are given no illusions as to the grimness of the business in which they are engaged. We owe it to them to rid ourselves of any false notions we may have about the nature of war."

—Office of War Information manual for the
U.S. motion picture industry, 1942

"Our enemies are innovative and resourceful, and so are we. They never stop thinking about new ways to harm our country and our people, and neither do we."

—George W. Bush, August 5, 2004

□　□　□

"Of all the enemies to public liberty war is, perhaps, the most to be dreaded because it comprises and develops the germ of every other. War is the parent of armies; from these proceed debts and taxes . . . known instruments for bringing the many under the domination of the few. . . . No nation could preserve its freedom in the midst of continual warfare."

—James Madison, *Political Observations*, 1795

"You work three jobs? Uniquely American, isn't it? I mean, that is fantastic that you're doing that."

—George W. Bush to a divorced mother of three,
Omaha, Nebraska, February 4, 2005

"You've got to accentuate the positive, eliminate the negative, latch on to the affirmative, don't mess with Mr. In-Between."

—"Mr. In-Between," music by Harold Arlen,
lyrics by Johnny Mercer, 1945

□　□　□

"Free societies are hopeful societies. And free societies will be allies against these hateful few who have no conscience, who kill at the whim of a hat."

—George W. Bush, September 17, 2004

"A country is not only what it does, it is also what it puts up with, what it tolerates."

—Kurt Tucholsky, German satirist, 1935

CONTENTS

FOREWORD
by J. R. Norton

THERE IS SOMETHING inherently underhanded about this book.

Micah Ian Wright—a keenly funny and observant writer who is furthermore blessed with an eye for art—clearly follows the news.

He is most likely a man with Google News in window #1, Truthout.org in window #2, and Foxnews.com in window #3, just to keep tabs on the latest universal talking points.

Certainly he's on top of current events. One could surmise that he's heard about the president's run-in with the Supreme Court on Guantánamo. One could suppose that he's familiar with the American Bar Association's lawsuit regarding presidential signing statements. And one could certainly presume that he's familiar with the Schiavo debacle, the embarrassing links between Cheney and Halliburton, the military setbacks in Iraq due to criminally poor planning, the civil setbacks in Iraq due to criminally poor planning, that awkward "civil war" thing, the embarrassing Republican refusal to pursue war profiteers, the whole scandal with the FDA refusing to review the morning-after pill, the collapse in public trust in the Republican party, the soaring number of terror incidents worldwide, the rise of an emboldened Iran (also see: North Korea, several feisty South American states, Russia), the gutting of the Small Business Association and EPA, and probably that extremely unpopular stem cell veto, as well.

Also: Michael Brown. Brownie. He did a heck of a job.

And yet—like a schoolyard bully who's already extracted a faceful of blood but just can't keep himself from delivering a few dozen extra punches—he insists on publishing yet another stack of devastatingly clever, elegantly dangerous, out-and-out gorgeously designed remixed propaganda posters.

And so at a time when America's war president—and the party *the American people* chose to put into power, give or take some hiccups in Ohio—have never needed his help more, Micah Ian Wright has instead chosen to deliver yet another bruising kick to the midriff.

Unsporting.

That's what this book is.

Absolutely unsporting.

SECTION ONE: THE WAR ON PRIVACY

I KNOW WHAT YOU'RE THINKING.

You're thinking: "Hey, I don't want the National Security Administration eavesdropping on my overseas phone calls." You know why you're thinking that? Because you don't understand freedom and the sacrifices necessary to maintain it. What do you have to hide? Are you a terrorist? Don't laugh —the terrorists are everywhere. Your neighbor is in on it with Osama Bin Laden. That "wedding" he's talking about attending next week? That's Al Qaeda code for a suicide attack. He's some kind of suicider.

Yeah, that's right—"suicider." Sure, it didn't used to be a word, but President Bush has used it several dozen times in public in the last five years[1] and if our president says it, then who the hell are you to question his decisions to add agentive endings to important words? Lest you forget, he's The Decider. The Decider has also decidered to tap your calls to make sure you're on the up-and-up.[2] Hell, only an Al Qaeder would have anything to complain about. As the president said, "If Al Qaeda is calling you, we want to know why!"

So . . . once again, why don't you want to tell Uncle Sam why Osama's calling you?

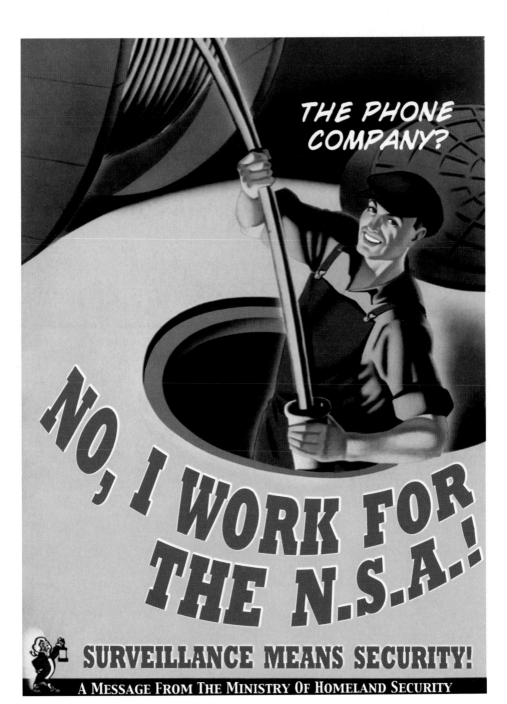

THE PRESIDENT SAID IT HIMSELF: "We're not mining or trolling through the personal lives of millions of innocent Americans."³ Sure, it was reported on that very same day that the telephone calling patterns of millions of Americans are being tracked by the NSA with the help of the nation's three largest telephone companies,⁴ but those claims were put forth by the lying, corrupt "elites" in the "liberal" media, so how true could they be?

Anyway, you can't blame Bush for using the tools that Congress gave him. When Congress passed the Communications Assistance for Law Enforcement Act in 1994, it required telecommunications companies to enable a tap on any call by remote command. It also authorized domestic eavesdropping by virtue of "court order, or other legal authorization." Bush has that very same "other authorization" by dint of being a wartime president, dammit!

Look, even if the NSA *is* trolling through your personal records and data-mining them in order to find six degrees of separation between you, Kevin Bacon, and this week's #3 boss of Al Qaeda, what do you care? It's not like the government ever takes information out of context and uses it to prosecute innocent people for being terrorists or anything, right?⁵

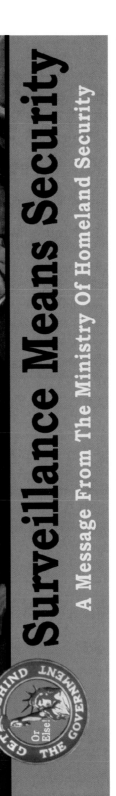

WOULD YOU LIKE SOME FREE HELP with your taxes? Sure, who wouldn't. Well, the Bush administration is eager to help. All you have to do is look the other way while they scrutinize confidential financial records from a vast international banking database and pore over transactions involving thousands of American citizens and corporations. Ignoring those possibly illegal searches won't take you any extra effort because the Treasury Department's already been secretly doing them since shortly after September 11, 2001.[6] All because they're searching for extra tax deductions you might have missed!

Either that, or they're looking for evidence that you're a sinister Al Qaeda suicider. Whichever.

Sure, I hear you saying to yourself "Uh, I didn't authorize anyone to snoop through my bank records! Do they have a warrant?" Never mind, friend, they don't need one! This program doesn't snoop . . . it merely reviews $6 trillion in daily transactions from the Swift Bank, a Belgian nerve center of the global banking industry. They're probably not even looking at your bank accounts unless you get money from overseas, and what are the odds of that in today's globally connected world of multinational corporations?

President Bush is just checking to see if you're getting a weekly paycheck from Al Qaeda's payroll department, chum, so I'd stop complaining or you might not get the government's data-mined tips on how to save big at the grocery store.

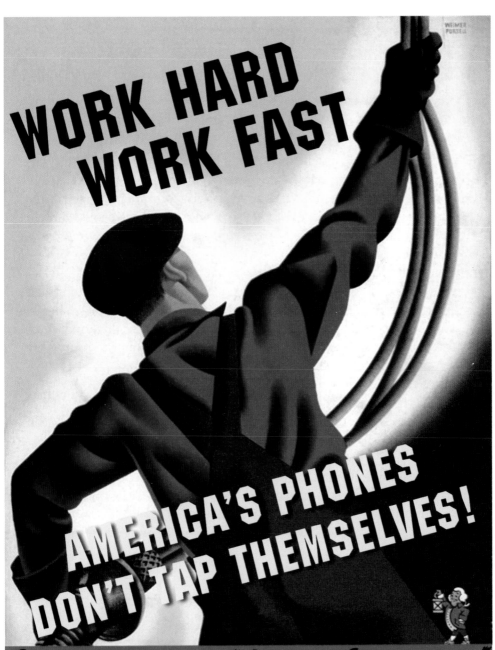

IT BOILS DOWN TO THIS: The president has to stop Osama from putting LSD in our water supply, and he can't do it if his hands are tied. Some naysayers claim that Bush's warrantless data collection not only violates the US Constitution but also diverts resources away from more practical steps, like inspecting cargo and hiring translators. Pshaw! What do those people know?

The problem is today's database-driven computerized surveillance automatically expands surveillance targets faster than the Foreign Intelligence Surveillance Act courts can rubber-stamp warrants. Say a suspected Al Qaeda suicider and/or foreign exchange student calls a pizza shop; the pizza shop's phone then goes on the trace list, as does the phone of everyone who calls the pizza shop—because who can possibly tell which customers are calling in for pizza and which are suiciders? It would just take too long for the president to go to court every time he wants to spy on all those Americans![7]

At first glance the idea of data-mining phone calls, airline reservations, ATM records, and credit card transactions might seem intrusive, but what if we didn't do it and those millions of suiciders here in America weren't caught? Who'd be laughing then? Sure, the phone records of reporters and newspapers are being searched,[8] but that's just to find out which Al Qaeda traitor in the government is leaking information about the president's super-duper-top-secret plans to spy on Americans . . . and certainly not to aid in any sort of retaliation or illegal cover-up. You can take that to the bank!

LOOK, WE'RE AT WAR. We know because the president says we are. Never mind that the silly Constitution stipulates that only *"the Congress shall have the power to declare war"*—everyone knows they haven't bothered doing that since World War II.

Besides, Congress gave Bush permission to do anything he desires when they passed the Authorization for the Use of Military Force (AUMF) against Iraq. Why, he told us so himself! A position report put forth by Attorney General Alberto Gonzales[9] describes President Bush as the "sole organ for the Nation in foreign affairs." This depiction was derived from Article II of the Constitution. While the powers of this "organ" already sound pretty limitless, according to the president's enablers, Bush reaps even *more* authority under the AUMF, passed in the wake of the 9/11 attacks. The Justice Department interprets Bush's AUMF to specifically sanction warrantless surveillance, even though Congress's resolution neither envisioned nor implied anything of the kind. The president feels that he alone understands Congress's will. This understanding is usually expressed through his practice of appending "signing statements" to laws that Congress has passed, such as when he signed an anti-torture law and attached a statement specifically exempting himself and his minions.[10] Again, Bush can do this because we're at war, you see. In Gonzales's own words, the strange chemistry of AUMF blended with Article II "places the president at the zenith of his powers," granting him "all that he possesses in his own right plus all that Congress can delegate."[11]

Hell, man, that's a lot of power! No wonder the president doesn't need any warrants: under this shockingly expansive neoconservative view of the Imperial Presidency, he's probably also usurped all the powers that the Supreme Court could delegate!

In fact, things run so well with a unitary power at the center of a vast web of surveillance and police power, we should probably come up with a nice comfortable name for a position like that. Familiar. Familial. Fraternal, even! How about "Big Brother"?[12]

THERE COMES A TIME each year when every man must take a month-long vacation and ignore the hubbub of the hoi-polloi. For George W. Bush, that month is August. In 2005, as our beloved leader was taking his annual r&r at his ranch in Crawford, Texas, he was warned that a Category 5 hurricane was headed for the Mississippi/Louisiana Gulf Coast area.[13] Just like in 2001, when he famously ignored warnings of "Bin Laden Determined To Attack In U.S.,"[14] the president ignored this gathering storm, too. He was so busy clearing brush for the television cameras that he failed to order FEMA to take any substantive action to prevent loss of life or property—not that it was in their power to do anything even if he'd asked them to. Over the prior four years, Bush had replaced competent FEMA leaders with well-connected cronies and siphoned every spare cent from FEMA's coffers to fund, yup, the War on Terror![15]

While Governor Kathleen Blanco of Louisiana sought to have the impending hurricane declared a national disaster before it hit, President Bush didn't cut short his vacation until after the storm hit the Gulf Coast and much of the city of New Orleans was already under water.[16] In fact, the day after the levees were overtopped and the flooding was well underway, Bush said that he thought the city had "dodged a bullet."[17] Later, after the flooding was live on TV for everyone in the world to see, he said that no one could have anticipated the failure of the levees, despite several such predictions in recent years including a briefing he'd sat in on just days earlier.

On September 2, FEMA chief and renowned Arabian horse expert Michael Brown took the president on a camera-friendly tour of the Gulf Coast. Brown was the living symbol of Bush's reshaping of FEMA from an agency staffed by competent experts to a poorly funded holding tank for political cronies.[18] Bush, who had appointed Brown in 2003, praised him, saying "Brownie, you're doing a heck of a job."[19]

Bush also expressed sympathy for his friend, Senator Trent Lott (R-MS), who had lost his multimillion dollar vacation home in the storm; "The good news is— and it's hard for some to see it now—that out of this chaos is going to come a fantastic Gulf Coast, like it was before. Out of the rubbles of Trent Lott's house— he's lost his entire house—there's going to be a fantastic house. And I'm looking forward to sitting on the porch."[20]

Yes, despite at least 1,836 deaths, an estimated $81 billion in damage, and over a million residents driven from New Orleans and forcibly scattered by the government across the United States, Bush no doubt envisions a fantastic new Gulf Coast emerging . . . one whiter, richer, and with far fewer Democrats in it. What's not to love?

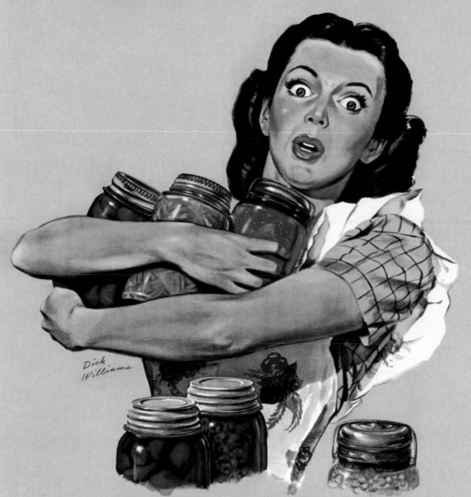

SO IT GETS A LITTLE WARMER . . . who cares? What skin is it off your nose if those Kennebunkport winters get a little easier for an old man to handle? Maybe it's true that your grandchildren won't be able to breathe, but you'll be dead from the poison we're putting in your air and water by then, anyway. Besides, the toxins we refuse to remove from the environment are probably making you infertile. Why, it'll be a miracle if your damaged offspring actually spawn a litter of their own! And assuming that they do, what are they going to eat after the hotter temperatures burn all the crops off the land? The future is overrated.

Look, the Earth is just in the middle of a routine cycle of cold-hot-cold. It's nothing to worry about . . . it's natural! And it's purely coincidental that this latest natural conversion from Ice-Age to Burning-Hot-Rain-Of-Fire-That-Scorches-All-Life-Off-Earth-Age started at the dawning of the Industrial Revolution.

Incidentally, guess how much it would have cost America to knuckle under to all those sinister foreigners and their Kyoto Treaty? $300 billion dollars![21] I don't know about you, but I think I'd rather have a cool war to watch on TV!

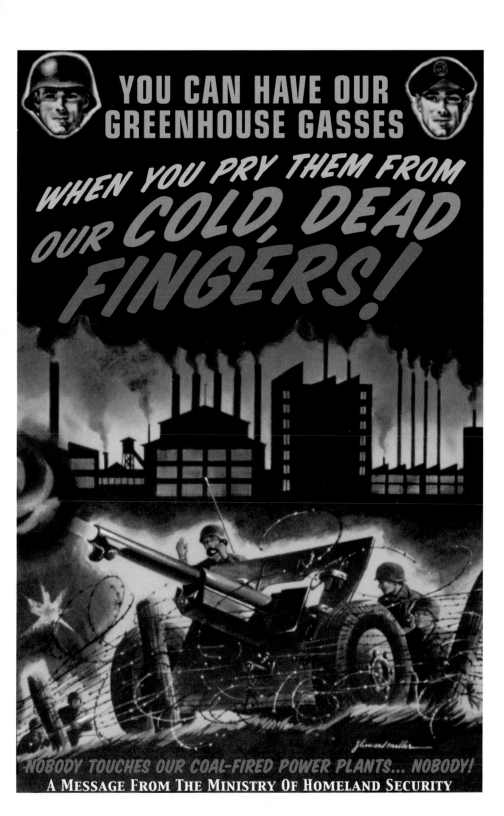

PRESIDENT BUSH HAS PROCLAIMED that America is addicted to oil. Yes, he seems to have only discovered this on January 31, 2006,[22] but some folks are slow learners.

With the fervor of the recent convert, Bush has taken to the road, saying his new catchphrase again and again. The president believes we should skip the current generation of gas/electric hybrid cars (and the last generation of electric-only cars shredded by General Motors) and push forward to the Hydrogen Car of Tomorrow!

He's right, those are the Cars of Tomorrow! Sure, it's mostly because they haven't been invented yet, nor has the foolproof hydrogen-pumping system we'll someday need to replace every single gasoline station with, but that doesn't mean we can't dream. Speaking of dreaming, where do you think all that wonderful hydrogen is going to come from? There's only one power source with the potential to crack that much water into hydrogen and oxygen. I'll give you one hint . . . it's pronounced "new-cue-lure."

And with those 100 new nuclear powerplants across America, we're going to need somewhere out-of-the-way and desert-y to stash all that highly radioactive waste. Volunteers, anyone? It's the least you can do to bring Tomorrow one step closer!

WHAT'S THAT? You don't like nuclear power? Well, neither does anyone else. That's why those hydrogen-powered cars will *always* be the Cars of Tomorrow! No one wants safe, efficient, reliable electric vehicles without a gazillion moving parts that break down all the time . . . not the car makers, not the repair shops, not the auto parts stores, not the local gas stations and certainly not ExxonMobil.

What ExxonMobil (among others) *would* like is for you to buy a four-wheel-drive Chevy Suburban LTZ 1500 (real-world mileage: about 7 mpg). Our patriotic oil companies would also like for the government to allow them to drill for oil in the Arctic National Wildlife Refuge. Heck it's not good for anything else, right? And don't worry about the animals. The Decider's father, George Herbert Walker Bush III has already taken care of all the thinking on that subject: "If you're worried about caribou, take a look at the arguments that were used about the pipeline. They'd say the caribou would be extinct. You've got to shake them away with a stick. They're all making love lying up against the pipeline and you got thousands of caribou up there."

Are you calling our president's daddy a liar?

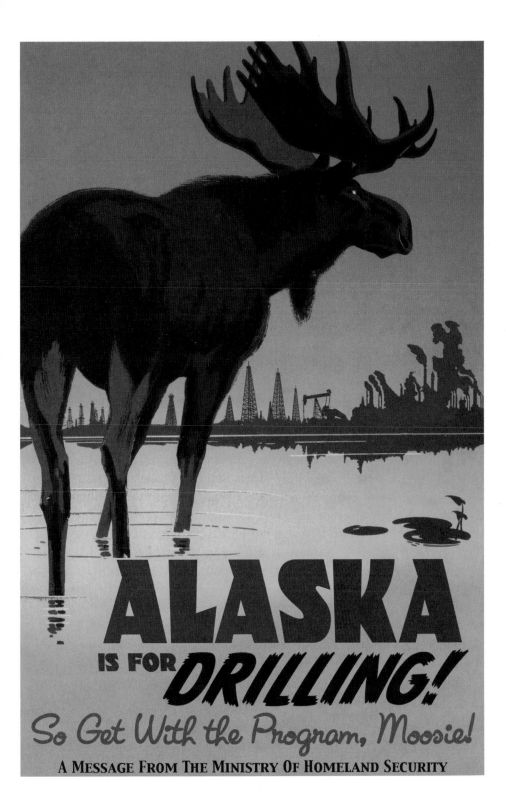

USUALLY WHEN YOU WANT SOMETHING and you don't mind paying for it, you just buy it. The Republican majority has brought this sensible, pro-consumer approach to Washington and put it to work for you! Let's pretend you're a defense contractor looking for some easy work where you don't have to do much of anything. Under the easy-to-use Republican system, you just invent some pointless make-work that you'd like the taxpayers to buy from you; determine what crazy, outlandish price you want; and then bribe the appropriate Congressmen. What could be easier?

Simple and straightforward as it is, paying for votes outright can get expensive. Rep. Virgil Goode (R-VA) cost defense contractor Mitchell Wade $90,000 in bribes, for example. Why, presidential-election fixer and Rep. Katherine Harris (R-FL) cost Wade $32,000 in bribes plus a $2,800 dinner, and all he got in return was her *attempt* to get him a $10 million government contract. She didn't even succeed! That's just not smart shopping. Luckily Wade struck gold with Rep. Duke Cunningham (R-CA), giving him almost a million dollars in cash, free antiques, and a boat . . . and in return, Cunningham threw Wade $150 million in hidden government contracts. Still . . . a million dollars out of pocket is a lot of money, how's a smaller operator supposed to compete?

Have no fear, there *is* a secret to getting government contracts on the cheap: The best way to a hypocritical family-values Republican's heart is through his crotch. Defense contractor Brent Wilkes, a $100,000-contributing "Pioneer" of President Bush's 2004 campaign, came up with the idea to throw a few poker-and-whores parties at the Watergate hotel. He easily raked in a few conservative congressmen, Pentagon procurement officials and even the #3 man at the CIA, Kyle "Dusty" Foggo.[23] Now that's good dollar-cost-averaging! And just think . . . because Wilkes was reimbursed for his out-of-pocket prostitute expenses by that fat Pentagon contract, it was really YOU who paid for those whores.

Free whores AND multimillion dollar contracts? You've got to give it to the Republican Party: they're just better at business.

Prostitution

Is a Good Way to Bribe Congressmen & CIA Officials

A MESSAGE FROM THE MINISTRY OF HOMELAND SECURITY

IMMIGRATION HAS BEEN A CONTENTIOUS issue in the United States ever since the Puritans landed at Plymouth Rock and began a long and storied tradition of stealing land and food from the natives. But one key thing has always brought each new group of American immigrants together with the Americans who were here before them: mutual hatred of any group which arrives after them.

Conservatives are all about maintaining America's traditional family values. And what could be more traditional than bigotry? It's a custom that we're proud to bring with us into the 21st Century.

Why, just this year the Oregon Republican Party platform officially supported a movement to deny citizenship to babies born on U.S. soil to illegal immigrants and legal immigrants who are not citizens. That would directly contradict the 14th Amendment of the U.S. Constitution, which states that "all persons born or naturalized in the United States, and subject to the jurisdiction thereof, are citizens of the United States." You have to go back to the 1960s to find better examples of race-baiting and political pandering for votes! It's enough to swell a *real* American's heart with pride.

You shouldn't worry about illegal immigration, though, because the Bush administration has a plan. Look no further than Bush's recent award to Halliburton of a $385 million contract to create an archipelago of permanent "detention centers" to deal with "an emergency influx of immigrants into the U.S., or to support the rapid development of new programs."[24] No word yet on what kind of "new programs" would require camps able to concentrate and hold up to 5,000 people.[25] But you should find yourself comforted by Bush's record of restraint and good judgment. I'm sure whatever those secret bases are for, they'll be the final solution to our immigration problems.

AMERICA'S BUSINESSES WORK BETTER when they're run by businessmen, not by government bureaucrats. The only way to remove red tape and to make businesses work smoother is to eliminate unnecessary government meddling in the free market.

Coal mining, for example, used to be seen by the government as a dangerous occupation. After Bush came to power in 2000, however, all of that changed. Bush filled the top positions at the two federal mine safety agencies—the Mine Safety and Health Administration (MSHA) and the Federal Mine Safety and Health Review Commission—with executives and lobbyists from the very same coal industry that they're now in charge of regulating.[26] They immediately set about their task of dismantling safety regulations and other burdensome government red tape.[27]

On January 2, 2006, twelve miners at the Sago mine in West Virginia were killed by a mine explosion. Sure, the Sago mine had 208 safety citations in the previous year, and yes, MSHA inspectors found forty-six safety violations at Sago in the last three months of 2005, including one less than two weeks before the disaster, but that just proves that Bush's changes haven't affected the fine job that MSHA inspectors do.[28] Okay, the proposed fines for those violations totaled just $2,286, and to some whining union officials it might seem the companies would rather pay such paltry fines than to fix expensive safety problems, but the new Bush MSHA understands what those dirty union types can't. By stressing mining companies' voluntary compliance with safety rules, everyone is served: employers *and* shareholders.

Don't imagine that it's only coal workers, either. President Bush has made it a primary goal of his administration to protect big business from workers, regulators, minimum wages, and lawsuits . . . and corporations and CEOs have flourished as a result. Just remember who to thank the next time you get your tax-free dividend checks from those millions of stocks that you own. Just don't try to drink your water, eat healthy food, breathe clean air, or fly on safe planes. America's business can't afford those luxuries!

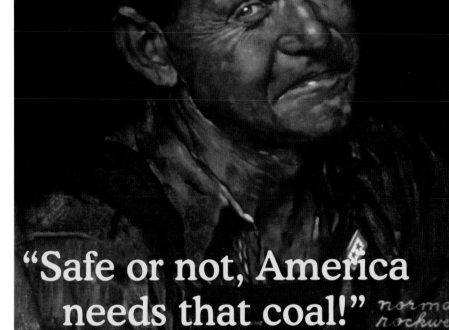

PRESIDENT BUSH IS A MAN OF CONVICTION. He'd have more of them, but the Republican Party controls the Congress. Ha! No, we're only joking. Dubya is a straight shooter. He knows what's good and bad for America and he's not afraid to speak his beliefs aloud. Just take the troublesome issue of gay marriage . . . please!

But seriously, for a primer on presidential leadership, just look at how boldly George Bush has stood up to "The Gays" and their sickening desire to destroy marriage. He has repeatedly brought the issue to the fore of American politics again and again, trying to save the marriages of good, honest Americans from destruction at the hands of distant "Gays." He's brought it up every two years, in fact, regular as clockwork! Usually right before an election, but that's probably a coincidence. Right?

WE LOST OUR SON...
WHEN HE MARRIED GAY!

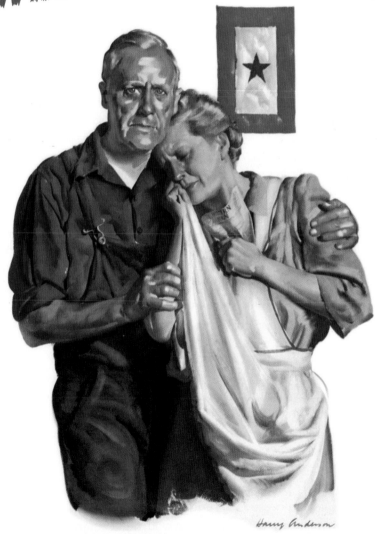

REAL AMERICANS SUFFER
WHEN GAYS MARRY!
A MESSAGE FROM THE MINISTRY OF HOMELAND SECURITY

FROM THE MOMENT HE TOOK OFFICE, George W. Bush has been concerned first and foremost with instilling a Culture of Life here in America. On his first day in office, January 22, 2001, the twenty-eighth anniversary of *Roe v. Wade*, Bush's first presidential act was to re-impose a Reagan-era "gag rule" (overturned by Bill Clinton) that prohibits U.S. funding of any domestic or foreign family planning agency that so much as mentions abortion to their clients.[29] President Bush is such a caring man that he worries about every fetus in every country, you see.

Bush understands that fetuses are innocent, but their mothers are crazed murderers. Yes, every single one of them. Steps must be taken in order to protect these unborn children, and Bush has done so in spades. Among other steps, he has cut government programs that provided access to information about abortion, signed into law a ban on late-term abortions, appointed several dozen anti-abortion judges to lifetime appointments, appointed two virulently anti-abortion judges to the Supreme Court, expanded the funding of highly ineffective "abstinence-only" sex education, attempted to ban abortions for female members of the military, and attempted to raid the records of women who had abortions at Planned Parenthood.[30]

Not merely content to prevent abortions, our fearless leader even feels that women shouldn't be able to prevent themselves from getting pregnant. His political appointees at the FDA overruled a panel of its own scientists and blocked widespread availability of the "Plan-B" emergency contraception drug, which merely prevents ovulation, fertilization, or implantation of a fertilized blastocyst. Bush's advocates at the FDA blocked over-the-counter access to the drug for over three years, claiming that "we could not anticipate, or prevent extreme promiscuous behaviors such as the medication taking on an 'urban legend' status that would lead adolescents to form sex-based cults centered around the use of Plan-B."[31]

Well, teen sex cults may be coming to your neighborhood soon because on August 24, 2006, after a showdown with Democrats in the Senate who refused to approve his interim head of the FDA, Bush blinked and made Plan-B available to adults over eighteen without a prescription. Not to worry, though, your teen's sex cult will be stymied by Bush's support of "conscience clauses" which allow pharmacists not to supply any prescribed drugs they object to based solely on religious grounds.[32]

President Bush has accomplished all of these blows against reproductive rights despite the fact that a consistent majority of Americans want abortion to remain legal.[33] This isn't surprising, since one-third of all women in the U.S. will have an abortion before the age of forty-five.[34] Murderers, each of them.

Yes, President Bush's most sterling contribution to the future of our Procreation Nation must surely be the millions of children who might otherwise not have been born! True, many of these children will be born into poverty and to parents who don't want them, but that's not the president's problem: he's pro-birth, not pro-life.

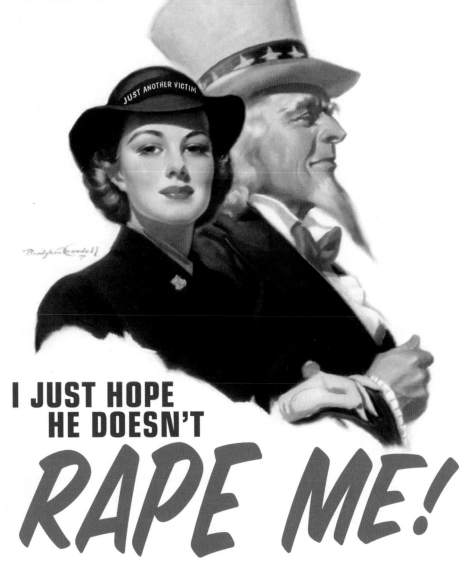

THE PRESIDENCY IS AN IMPORTANT JOB that takes a lot of concentration. Protesters get in the president's way and he should never even have to know that they exist. It was shameful back in 2000 when Bush's limousine was egged at his inauguration. Bush was afraid to walk the parade route until he entered the area of seating paid for by invited Republican supporters.[35] This type of nuisance had to be stopped, and the president's advisors knew just how to do it.

Policy was changed so that when Bush travels, the Secret Service visits the location ahead of time and orders local police to set up "free speech zones" where citizens opposed to Bush's policies are quarantined out of the view of the president and the media. Unlike naïve citizens who thought our entire nation was a "free speech zone," Bush knew better! The White House also now sends advance teams of handlers to all of the president's events to screen audience members and reporters for loyalty to the president and his policies. Potential troublemakers who might disrupt these contrived public forums are ejected and sometimes arrested.[36]

For the 2005 inauguration, the full brunt of the police state was brought to bear in Washington, DC: a 100-block area surrounding the inaugural parade route was blocked off to normal traffic. School was canceled in the city. In addition to 3,800 local police, some 7,000 military troops were mobilized and at least 3,000 officers were brought in from surrounding counties, as well as from cities as distant as Miami. Snipers were visible on area rooftops.[37] Media reports made no bones about the fact that the clampdown was aimed against protesters seeking to express their opposition to the Bush administration.

In addition to the police presence, the administration's inaugural committee took steps to limit access to the route, not only for protesters, but for the general public as well. This time around, instead of egg-throwing anarchists, most of Pennsylvania Avenue was occupied by bleachers reserved for Bush campaign donors—not for commoners who hadn't paid the price of admission.[38] That certainly shows where the president's true loyalties lie . . . and it's not with the spirited debate necessary for a functioning democracy.

38

THERE'S ONE CASUALTY of President Bush's war in Iraq that never gets counted by the media: the city of New Orleans. Before the flooding of New Orleans, President Bush calmed those who might be worried: "To those of you who are concerned about whether or not we're prepared to help, don't be, we are. We're in place, we've got equipment in place, supplies in place, and once the— once we're able to assess the damage, we'll be able to move in and help those good folks in the affected areas."[39]

Even though more than a third of Mississippi's and Louisiana's National Guard troops were either in Iraq or away from their home states supporting the war effort, the National Guard said there were more than enough at home to do the job.[40] That wasn't quite accurate. There weren't enough helicopters to repair the breached levees, for example, or to rescue people trapped by the floods. Nor were there enough Louisiana Guardsmen available to patrol against looting or to help with rescue efforts. The situation was the same in Mississippi. Troops had to be brought into the area from all across the nation.[41]

The saddest thing about the New Orleans flooding is that it was completely preventable . . . if not for the president's war in Iraq. The president once said, "I don't think anybody anticipated the breach of the levees." Yes, no one, except the U.S. Army Corps of Engineers who were working on federal projects to strengthen and raise the New Orleans levees[42] and FEMA, who in early 2001 ranked potential flooding damage to New Orleans as among the three likeliest, most catastrophic disasters facing the United States.[43] Even worse, knowing it was bound to happen didn't do anything to change the administration's policies. Walter Maestri, emergency management chief for Jefferson Parish, said of the Bush administration's slashing of levee restoration: "It appears that the money has been moved in the president's budget to handle homeland security and the war in Iraq, and I suppose that's the price we pay."[44]

Sadly, that *was* the price 1,836 residents of New Orleans and the city itself had to pay for Bush's neglect of common-sense homeland security just two years later. The same price that New York City paid in 2001. Which American city will be next?

A LONG-LOST TRANSCRIPT of the Bush administration's first press conference was recently discovered jammed behind a shredder in the White House. It is presented here verbatim:

PRESS SECRETARY: Good morning, White House press corps. This is all off the record and not for attribution. New Sheriff in town. Let's go over a few changes in protocol. Here's how things will work now: We will do stuff. Then, we'll prepare a press release about it and give it to the media. Finally, you'll read our press release on the news or print it in your paper. The public gets informed and you're home by 4 p.m. Everyone wins!

Oh, and fair warning: Anyone who deviates from the message will be deemed biased and politically motivated. We came up with a catchy name for you: The Elite Liberal Media. Nice, huh? That reminds me—Helen Thomas, could you move to the back of the room, please? Fantastic.

Next up, to help things run smoothly, we've established a hierarchy for reporters seeking interviews with administration officials. Access will only to be granted to newspapers and networks that give the White House favorable coverage. Should no friendly reporters be available, the gay male prostitutes we've dressed up as reporters and hidden within your ranks will ask leading questions. Speaking of which, everyone say "hello" to Jeff Gannon.

If no literal prostitutes are available, figurative prostitutes will be paid to spread the administration's version of events. You all know Armstrong Williams, right? He can tell you how it works. We're always hiring.

Regarding PBS . . . Is Bill Moyers here? You got a new boss, funny guy. Leave your credentials with the guard at the gate. Next time, try being fair and balanced, old man. And don't forget your tote bag.

To make it harder to question or dispute us, we'll be classifying documents like crazy and barring you from Federal Advisory Committee meetings.

One last thing, we're banning TV cameras from recording the return of caskets and wounded soldiers from our war in Iraq. What war in Iraq? Well, it's a few years off, but it never hurts to prep the public early with a few "Saddam = Hitler" articles, you know? Judith Miller from *Times* is circulating a few Weapons of Mass Destruction stories for you to swallow. Y'know. If you can.[45]

Thankfully, the transcript ends there.

PRESS AWARD

FOR SUPPORTING WAR
KEEP SCARING AMERICA • REPORTING LIES • IGNORING TRUTH
A MESSAGE FROM THE MINISTRY OF HOMELAND SECURITY

Distributed for the issuing agencies by the Office of War Information

A SOUTH AMERICAN FORMER MILITARY OFFICER who once orchestrated a failed coup d'état against the government? Sounds like America's kind of guy! We've eagerly aided all sorts of pro-business brutal dictators south of the Rio Grande, and there's always room for one more at the table, just so long as he follows orders well.

Oh, but wait, this guy, Hugo Rafael Chávez Frías, is some kind of anti-imperialism leftist who believes in a policy of helping out the poor. Who let him get elected? He doesn't like even like corporate globalization or United States foreign policy, despite the fact that Americans buy a bunch of his oil. The nerve of some people. What's his problem, is he trying to end up on the same pile as Allende and Mossadegh?

Chávez was elected president in 1998 on promises of aiding Venezuela's poor majority, and was reelected in 2000. Get this: he bribes the poor to vote for him by combating illiteracy, malnutrition, disease, and poverty. Teaching people to read—what a transparent ploy to garner votes. What's next, giving them jobs? Hope?

Chávez is a creep, especially because he uses our own tactics against us. He's taken control of congress, the courts, trade unions, electoral commissions, and the state oil company, reserving all government business exclusively for his cronies.[46] Normally we wouldn't mind any of this, except his cronies aren't our cronies.

In 2002, Chávez survived a brief two-day coup d'état attempt by generals in the Venezuelan military. His temporary replacement, the head of the Venezuelan business-owner's association, announced a number of decrees whereby he declared himself the ruler of Venezuela, dissolved the National Assembly, declared void the country's Constitution adopted by national referendum in 1999, fired all the judges of the Supreme Court and the National Electoral Court, and repealed forty-nine laws which did things like raise the royalties paid by foreign oil companies for Veneuelan oil. In one day, this guy did what George Bush has taken almost six years to do!

Alas, it was not to last. Those measures turned the people against the coup plotters, and hundreds of thousands of citizens confronted the military and restored their elected president. Chávez has accused the United States and the CIA of helping fund and plan the coup in order to get cheap access to Venezuela's oil, but everyone knows that's ridiculous. It's not like the United States is addicted to oil. True, it was recently discovered that the Bush administration has secretly funneled $26 million dollars to Chávez's electoral opponents since 2002,[47] but that's just spreading democracy, right? Because George W. Bush would never do anything illegal to secure another country's oil. Right?

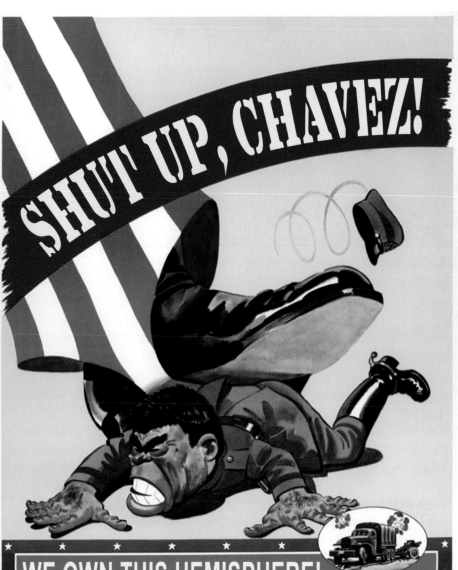

SHUT UP, CHAVEZ!

WE OWN THIS HEMISPHERE!
Democracy isn't real unless the USA approves the outcome!
A MESSAGE FROM THE MINISTRY OF HOMELAND SECURITY

HEY, SPEAKING OF GEORGE BUSH doing something illegal to secure another country's oil, didja hear the one about Iraq?

Depending on whose numbers you believe, somewhere between 40,000 and 200,000 Iraqi civilians have heard it.

Sadly, we'll never know exactly how many Iraqis were victims of Bush's funny joke because, as General Tommy Franks said, "we don't do body counts." That's bullshit, of course. We live in the Information Age—if it was possible to compile accurate casualty figures during the Civil War, then it can be done in Iraq. The only reason the Bush administration isn't doing it is because they don't want civilian deaths to become a topic of public debate.

IraqBodyCount.org (IBC) does, though. The website compiles documented war-related violent deaths that have been reported by at least two independent English-language media sources. At the time of publication, IBC's minimum documented death toll currently stands at more than 40,000 innocent civilians.

At the other end of the scale is the Lancet Study which, as of its publication in September 2004, pegged the civilian death count at 98,000. The study's main author says that now the total death toll in Iraq could possibly be as high as 200,000.[48]

Whoever's numbers are accurate, four facts shine through: first, a large majority of Iraq's civilian casualties caused by U.S. forces have been from our use of artillery and aerial weaponry; second, the majority of the civilians killed by these "stand-off" weapons were women and children;[49] third, the rate of civilian deaths is increasing;[50] and fourth, killing between 40,000 and 200,000 innocent civilians in the name of bringing them freedom is repugnant.

IN THE BEGINNING, there were forty-nine countries in the Coalition of the Willing. Since the invasion, though, seventeen nations have pulled their troops out of Iraq. Our chief foreign ally, the United Kingdom, only has 7,000 soldiers in-country versus America's estimated 140,000. Korea has 2,300 troops in Iraq. Italy's our third-best-friend with 1,600. Nineteen other countries are contributing between 900 and as few as thirty troops each. Not a lot of foreign troops, overall.

But America has one ally that the terrorist insurgents weren't counting on: the almighty dollar! Yes, our *real* chief allies in Iraq are Private Military Contractors (PMCs), or, as they used to be called, "mercenaries." These modern "security consultants" perform "risk management" for the oil pipelines and act as "aggressive security" for well-heeled foreigners in Iraq. No one, including the U.S. government, knows for sure how many private military contractors are working in Iraq, but estimates hover around 25,000.[51] So, to put it bluntly, we've bought more mercenaries than all the soldiers our foreign allies have contributed put together.

While coalition soldiers involved in war crimes against Iraqis can face court-martial and military discipline, PMCs are guaranteed immunity from Iraqi law, and as civilians, they're also not accountable to the Uniform Code of Military Justice.[52] So, in essence, 25,000 armed men roam Iraq with license to do anything they want without being punished . . . and they do.

Several hundred shootings, assaults, robberies, alleged murders, and other crimes have been committed by contractor cowboys in Iraq without rebuke, to say nothing of their involvement with the torture at Abu Ghraib.[53] PMCs from Zapata Engineering even went so far as to get into a gunfight with Marines in Iraq, but were merely sent home to America as punishment. Then again, when they're making more than $300,000 a year to shoot unarmed civilians in Iraq, maybe that's the only kind of punishment these mercenaries can understand.[54]

THE BUSH ADMINISTRATION asserts the authority to hold indefinitely citizens of any nation (including Americans), without regard to constitutions, international human rights treaties, laws foreign or domestic, and regardless of where or how these people are captured. These detainees have no access to a lawyer, no right to a trial, no right to judicial review of their extralegal imprisonment, and can be tortured. During oral argument before the Ninth Circuit Court of Appeals, the Bush administration stated that its position would be the same even if it was summarily executing the detainees.[55]

The administration justifies this behavior by claiming that Taliban fighters, Al Qaeda terrorists, and innocent teenagers on their way to weddings[56] are "enemy combatants" who do not have the status of either regular soldiers or that of guerrillas, nor are they part of a regular army or militia. After the invasion of Afghanistan, Bush immediately used this newfound authority "on the battlefield," rounding up about 660 "enemy combatants" from forty-two different countries and shipping them to the secretive "Detention Camp X-Ray" in Guantánamo Bay, Cuba.[57]

Realizing later the implications of such a sinister sounding name, Camp X-Ray was closed and the detainees were moved to Guantánamo's Camp Delta (a.k.a. "HappyFunTowne") where they've been held incommunicado for years.

Well, most of them, anyway.

Turns out that an awful lot of the people captured and sent to "Gitmo" seem to have been innocent bystanders to our war. Contrary to Bush's claims of their having been captured in combat, revelations proved that more than half of the inmates were simply arrested by Pakistani police. Others were simply foreign aid workers in the wrong place at the wrong time. There is only evidence for as few as 20 percent of the Gitmo detainees ever having been involved with Al Qaeda.[58]

Of the 759 detainees the administration admits to holding over the years at Gitmo, 192 of them have been freed since the camp opened. The military estimates another 120 will be eligible for transfer or release at some point in the future. Another 95 were transfered to foreign governments for imprisonment or questioning. After they're gone, only 340 detainees will remain at Guantánamo.[59] So far, well over half of these sinister "enemy combatants" turned out to be not so bad after all.[60]

To be fair, however, although Defense Secretary Donald Rumsfeld once said the detention cells at Guantánamo were reserved only for the "worst of the worst," he didn't specify exactly *what* they were the worst at. Evidently, many of them were simply the "worst" at running away from greedy Afghans, eager to turn in their tribal enemies and any random foreigner for the $30,000 bounties the United States military was paying for "enemy combatants."

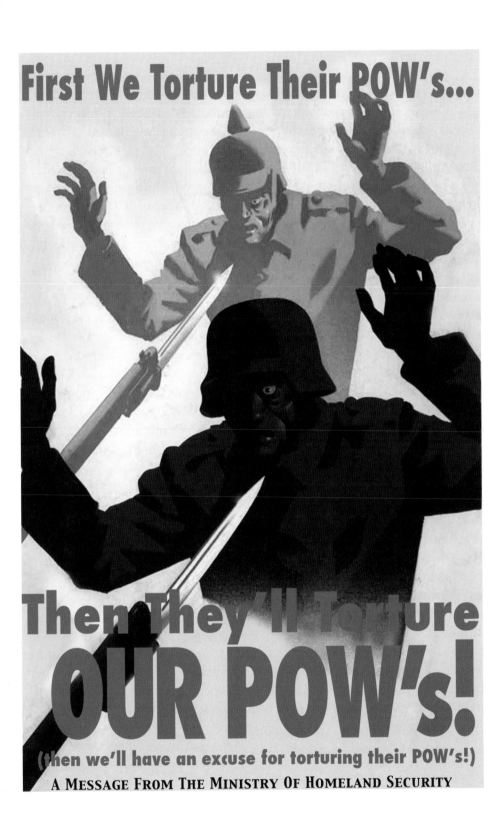

TO WIN THE WAR ON TERROR, President Bush can't be satisfied with trolling Afghanistan, scooping up Taliban holdouts, Al Qaeda suiciders, teachers, and innocent aid workers. No, he's cast his net wider to include the entire world through the use of "extraordinary renditions."

According to the Council of Europe, about a hundred persons had been kidnapped by the CIA on European territory and subsequently handed over to foreign countries for varying degrees of torture.[61] Said to former CIA case officer Bob Baer, "If you want a serious interrogation, you send a prisoner to Jordan. If you want them to be tortured, you send them to Syria. If you want someone to disappear—never to see them again—you send them to Egypt."[62]

It certainly could be considered "extraordinary" when you're walking down the street and an unmarked van screeches up onto the sidewalk ahead of you, four men jump out, punch you in the stomach, throw a black bag over your head, and muscle you inside. Imagine the "extraordinary" sensations as you're kicked and stomped into submission and then feel shackles go around your wrists and ankles and a gentle pinprick at your arm as you're sedated. When you next awaken, you're in an "extraordinarily" different country where you're then interrogated and tortured in quite an "extraordinary" manner.

German citizen Khaled el-Masri filed a lawsuit against the CIA claiming he was similarly kidnapped, detained, and tortured for five months because of a similarity between his name and terror suspect Khalid al-Masri. When the German government protested, his captors admitted their error, blindfolded him, flew him back to Europe, and left him on a hilltop in Albania to find his way home through the night and fog.[63] The CIA has issued no apology, nor have they claimed that el-Masri's story is untrue. Their only response has been to insist that his case be dismissed on the grounds that a public trial would expose what they're up to and threaten national security.[64] What can we say, Khaled, you live in extraordinary times.

Interestingly, although the CIA has refused to admit that any of el-Masri's claims are true, President Bush himself recently admitted the existence of the CIA's secret prison system when he transferred fourteen "key terrorist leaders" from CIA custody to Guantánamo—just in time for the 2006 midterm elections. The president had no revelations about any other secret prisoners or what sort of extraordinarily good times they might be having in America's secret prisons.

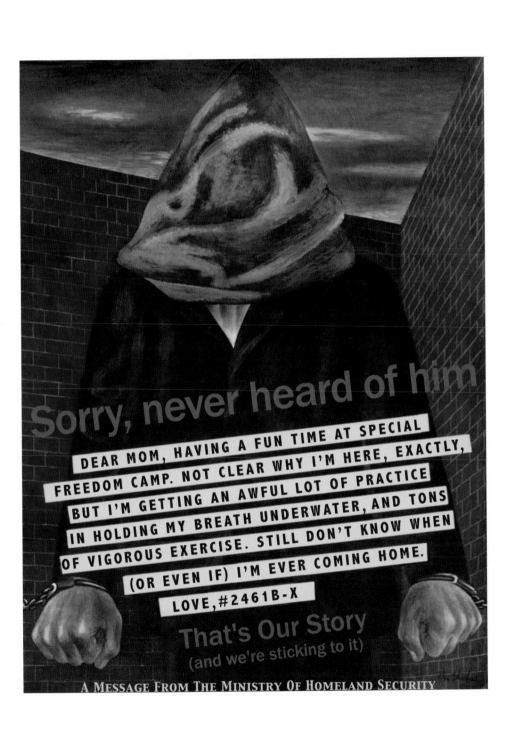

EVENTUALLY ALL GULAGS FILL UP. Then you've got to do something about the overcrowding. George Bush's solution was elegant: a few cursory kangaroo court trials followed by swift executions would free up some holding pens at Guantánamo Bay. Bush announced his intention to prosecute the enemy combatants in Gitmo not under the laws of the United States judicial system, nor even the streamlined Universal Code of Military Justice, but instead by a new third form of "justice" that Alberto Gonzales had cooked up: unreviewable "military commissions."

These "military commissions" that Bush attempted to carry out were quite unusual: the presiding officers were authorized to consider secret evidence that the accused had no access to and no opportunity to refute. Evidence obtained under torture was admissible. The accused could only use attorneys and translators that had been approved by the military (which dragged their feet clearing them). Any commission could be shut down without warning, and without explanation at any time by the general in charge (like, say, if the defendant was about to be exonerated).[65] You know, the standard, typical legal rights you might find in a courtroom in, say, Germany, circa 1942.

On June 29, 2006, the Supreme Court ruled that President Bush did not have the authority to set up these war crimes tribunals and that the commissions were illegal under both military law and the Geneva Conventions.[66] That's not what Bush heard, though: "They were silent on whether or not Guantánamo— whether or not we should have used Guantánamo. In other words, they accepted the use of Guantánamo, the decision I made."[67] Uhm . . . yeah, that's one interpretation of events. Another is that they slapped him down like a psychotic dictator with delusions of grandeur.

On August 2, 2006, Bush unveiled his new rules, designed with the ruling in mind. The changes actually expanded the reach of his "commissions" to include people who weren't members of the Taliban or Al Qaeda, and who are not directly involved in acts of terrorism. This essentially means anyone on Earth. As John D. Hutson, the Navy's top uniformed lawyer from 1997 to 2000, put it, the rules allow the government to tell a detainee: "We know you're guilty. We can't tell you why, but there's a guy, we can't tell you who, who told us something, we can't tell you what. But you're guilty."[68]

Yes, I'm sure that's what the Supreme Court had in mind when they ordered Bush to redesign his phony tribunals: a through-the-looking-glass trial in which 2+2=5.[69]

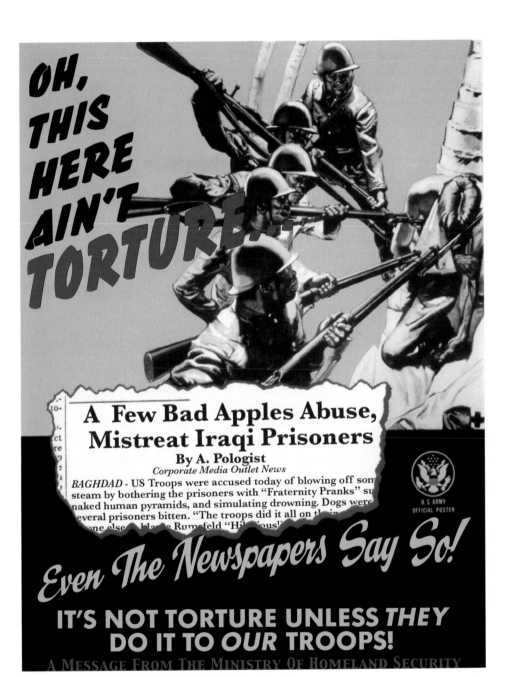

WHEN WE INVADED IRAQ in March 2003, a mystifying 75 percent of Americans supported the president.[70] Maybe the American people were just looking for a little payback for 9/11 and they wanted to believe the president's deliberately misleading campaign to lump Saddam and Osama together into one fearsome Islamic fundamentalist enemy. Or perhaps they believed the president when he claimed that Saddam Hussein was building nuclear weapons and refusing to allow United Nations weapons inspectors to search Iraq for them. On second thought, perhaps it's not so surprising that people believed these lies: they were repeated ad nauseum by the administration.

What *is* surprising is that President Bush seems to have told these lies so often that he actually *still* believes them, especially his lie about Saddam not allowing U.N. inspectors into Iraq. The facts are that Iraq surrendered to the U.N. Security Council and allowed experts to conduct more than 700 inspections of potential weapons sites from November 27, 2002, to March 16, 2003.[71] The inspectors said they could wrap up their work within months. Instead, Bush unilaterally declared that "diplomacy had failed," recalled the inspectors, and started the invasion the next day.[72] Yet he continues to tell America that the reason we went to war was because Saddam never let inspectors INTO Iraq.

On July 14, 2003, three months after the start of the war, Bush said: ". . . did Saddam Hussein have a weapons program? And the answer is, absolutely. *And we gave him a chance to allow the inspectors in, and he wouldn't let them.* And, therefore, after a reasonable request, we decided to remove him from power."[73] The president blatantly denied clear history, and the *New York Times* didn't even bother to report it. Having gotten away with it once, Bush has wheeled this startling lie out three more times since,[74] most recently during a graduation speech at West Point on May 27, 2006.[75]

Well, it certainly wasn't the first time Bush lied to our troops. Nor will it likely be the last.

SECTION FOUR: THE WAR ON THE MILITARY

THIS WAR IS A LIE.

The president's lies extend through it all: lies about the goals of the war, lies about the reasons for the war, lies about how the war was prosecuted, the lies that the war was "over," and beyond. There's no reason to go over each and every lie here—if you need the gory details, check out the excellent "Lie By Lie" time-line published by *Mother Jones* magazine and available on their website (motherjones.com). Other good sources of information include truthout.org, wikipedia.org, talkingpointsmemo.com, mediamatters.com, the Center for American Progress website (americanprogress.org), and dozens of other sources.

No, instead, let's accept the bloviating right-wing punditry's constant siren-call to "never mind" the lies about why we went to war and to concentrate instead on winning it. Frankly, we have to, because it's impossible for America to unbreak eggs, to unmurder children, or to un-tell the lies which led us into this nightmarish quagmire. Hell, with that much horror in the rear-view mirror, looking forward to "victory" in Iraq is all a sane person can do.

Unfortunately, because of the manner in which the president and his crew have managed to botch the job in Iraq, there's no victory in sight. At every turn this administration has made the worst possible decisions. From allowing professional liars like Ahmed Chalabi to influence the administration's planning, to rejecting all advice from the State Department, to willfully ignoring the influence that Iran has had on Iraqi Shiite politics since 1500 A.D., to assuming that when Saddam Hussein was overthrown Iraqi society would be docile and grateful, to firing the entire Iraqi military, to imposing shock therapy market liberalization, to frittering away $18 billion dollars in "reconstruction money," to ignoring death squads operating out of the Iraqi government, to ignoring the sectarian violence which has blossomed into a civil war between religious factions, it's obvious that The Decider has decided just about everything wrong.

DO YOU BELIEVE THAT SADDAM HUSSEIN'S government possessed Weapons of Mass Destruction in 2003? If so, you're among the 50 percent of Americans who believe this fiction, according to a recent poll.[76] Half of this country has withdrawn from reality. Amazing, isn't it?

The reality of the situation is this: on September 30, 2004, after a sixteen-month, $900-million-plus investigation, America's WMD hunters issued the Duelfer Report. It declared that Iraq had dismantled its chemical, biological, and nuclear arms programs in 1991 under U.N. oversight. While no one believes that Saddam had forsworn such weapons forever, no proof has ever been found that he'd tried to make any since 1991.[77]

It doesn't end there, however: as of summer 2006, 64 percent of Americans believe that Saddam Hussein had strong links to Al Qaeda; 72 percent believe that the Iraqis are better off now than they were under Saddam Hussein; 55 percent think history will give the U.S. credit for bringing freedom and democracy to Iraq.

This is what happens when media outlets such as Fox News dumb down the truth for a partisan audience. Self-delusion will always find an willing audience . . . it's far preferable to inconvenient truth. The biggest problem arises when the rest of the corporate media news outlets study Fox's ratings with jealous eyes and attempt to remake themselves into a string of "me-too!" right-wing faux news outlets. The fact checking gets lost in their rush to proclaim their partisan spin for commercial gain.

Or, as Fox News invited us to speculate upon and fantasize about during the Israeli-Hezbollah war in August: "Are Saddam Hussein's WMDs now in Hezbollah's hands?"[78]

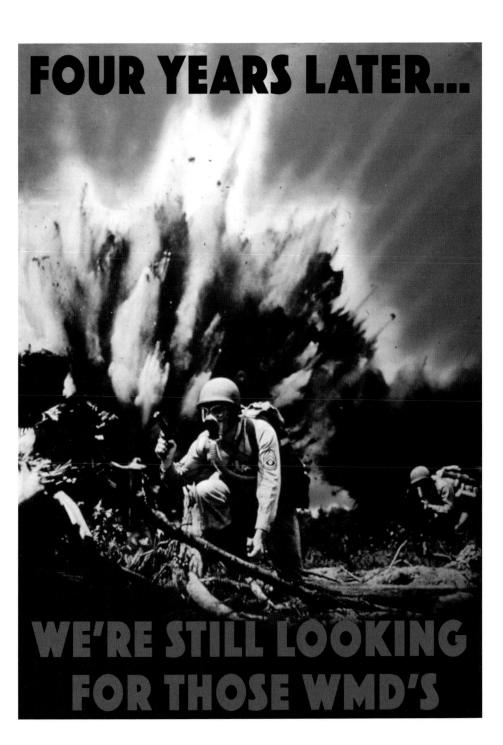

HERE'S A LITTLE-HEARD FIGURE: since the War on Terror began, over 40,000 troops have deserted.[79] Replacing those soldiers is growing difficult. The Army missed its 2005 recruiting goals by 7,000 soldiers despite offering enlistment terms as short as fifteen months and bonuses as high as $40,000.[80] Seems like it's hard to recruit volunteer meat for the grinder during a pointless war, but the only alternative, a new draft, would be political suicide for Bush.

While there isn't a formal draft, the Army *has* twisted a few arms to keep its numbers up. Some 12,500 soldiers are serving involuntarily under "stop-loss"[81] orders which force soldiers to continue serving for up to eighteen months beyond the end of their voluntary commitments to the military. Fifty thousand soldiers in all have been pressed into service under this policy,[82] and this practice has become known as a "backdoor draft."

To make up for its ongoing shortfall, the Army has changed its criteria for new recruits. The new recruit age limit was raised from 35 to 42.[83] The Army also began signing up high school dropouts without a GED.[84] Worse, the Army quadrupled its intake of "Category IV" recruits with an average IQ of 81 to 91 (vs. the Category I recruit average IQ of 113).[85] The Army had long resisted this move, recognizing that dumb soldiers are harder to train, bring down the performance of their entire unit, and make more mistakes, some of them fatal.[86]

But dropouts, geezers, and morons are nothing compared to recruiting criminals. Since 2001, the Army has doubled its percentage of recruits who enter under "moral waivers" for criminal convictions.[87] The soldier who stands accused of leading the gang rape of a fourteen-year-old Iraqi girl in Mahmudiya and then murdering her entire family was an unemployed high school dropout with three misdemeanor convictions before he joined the Army.[88]

Additionally, the Pentagon stands accused of abandoning its policy against recruiting neo-Nazis, adopted after former soldier Timothy McVeigh committed the worst act of domestic terrorism seen in America. A report by the Southern Poverty Law Center claims that "large numbers of neo-Nazis and skinhead extremists continue to infiltrate the ranks of the world's best-trained, best-equipped fighting force"[89] and points to a hate-magazine article written by a former Special Forces officer, urging skinheads to join the Army: "Light infantry is your branch of choice because the coming race war and the ethnic cleansing to follow will be very much an infantryman's war. It will be house-to-house, neighborhood-by-neighborhood until your town or city is cleared and the alien races are driven into the countryside where they can be hunted down and 'cleansed.'"[90]

Our military and political leaders are looking the other way as the military is polluted with the stupid, the immoral, the criminal, and the incompetent. Then again, why should the military be held to a higher standard than their civilian leadership?

MID-LIFE CRISIS?

Come
JOIN THE ARMY!

NOW ACCEPTING OLD MEN, AUTISTICS, NEO-NAZIS,
FOREIGNERS, CRIMINALS AND JUST ABOUT ANYONE ELSE
(EXCEPT GAYS)

A MESSAGE FROM THE MINISTRY OF HOMELAND SECURITY

WHILE THE ARMY HAS EVIDENTLY been scooping up simpletons, gang-bangers, murderers, rapists, near-retirees, and neo-Nazis as fast as recruiters can get them to sign on the dotted line, they've been simultaneously expelling one group of soldiers as fast as they can find them: gays.

Since the military's anti-gay "Don't Ask, Don't Tell" policy was created in 1993,[91] over 11,000 gay armed service members have lost their careers,[92] including soldiers in the critical areas of intelligence, medical, air traffic control, and linguistics. Over 300 gay linguists with essential language skills in Farsi, Chinese, and Russian have been discharged. Despite a crisis-level shortfall of Arabic speaking troops, fifty-five Arabic linguists have been eliminated under DADT.[93] Discharging and replacing these thousands of gay soldiers has cost the Pentagon nearly $364 million, according to a blue-ribbon panel that included former Defense secretary William Perry.[94]

Banning gays isn't only expensive, it's pointless. Surveys of military personnel and civilians show support for the ban on gays in the military has plummeted since the 1990s. Most troops seem think that the ability to do the job well is what matters. Only America's politicians continue to think that integrating gays will destroy the military . . . although doing so certainly hasn't hurt the Israeli military's ability to kick the crap out of Lebanon.

Yes, twenty-four foreign militaries—including allies Canada, France, Great Britain, France, and Israel—have lifted their gay bans with few difficulties.[95]

The fact is that despite the Pentagon's best efforts, there are an estimated 65,000 gay troops currently serving on active and reserve duty.[96] These gay and lesbian Americans are just as patriotic as straight Americans and want the right to serve—and die—for our nation without fearing intrusive investigation into their private lives.

And by intrusive, they do mean intrusive: Bleu Copas, a decorated Arabic language expert, was discharged by the Army after a string of anonymous emails identified him as gay. Copas was repeatedly asked by his superiors if he was gay, despite the "Don't Ask" half of the policy. He denies that he ever told his superiors he was gay. His accuser was never identified.

When Army investigators investigated Copas, one of the questions they asked him was if he was involved in community theater. Yes, evidently performing in *Ragtime* is grounds for dismissal of essential Arabic translators these days. I'm sure Osama Bin Laden is pleased that he and George Bush agree on this crucial issue.

ACCORDING TO A LE MOYNE COLLEGE/ZOGBY POLL[97] released in February 2006, 74 percent of the military troops then serving in Iraq had served multiple tours in Bush's war: 26 percent were on their first tour of duty, 45 percent were on their second tour, and 29 percent were in Iraq for a third time or more. Oddly, only 23 percent of them wanted to heed Bush's call to stay in Iraq "as long as they are needed." An astonishing 72 percent of them thought the U.S. should exit the country within the next year. A full 29 percent thought we should leave immediately. A whopping 89 percent of reservists serving in Iraq said we should leave Iraq within a year.

Yet, when Rep. John Murtha (D-PA), a Vietnam War veteran, brought up the same concept in Congress, he was decried by the Bush administration's sock puppets in Congress and the media as a traitor who wanted to "cut and run" from Iraq. Murtha and 72 percent of the troops that we're supposed to "support": cowards, all.

The Zogby poll also showed that 42 percent of those serving in Iraq said the goals of the U.S. mission in Iraq were unclear to them. But then again, maybe those troops know more than we do . . . unlike 50 percent of American civilians, a full 93 percent of the troops understood that finding Saddam's WMDs was *not* the real reason for the war.

Thirty percent of the troops in February 2006 felt that the Department of Defense had failed to provide adequate equipment, such as munitions, body armor, and vehicle armor plating. This despite the furor that broke out fourteen months earlier when Specialist Thomas Wilson of the Tennessee National Guard had the temerity to criticize Secretary of Defense Donald Rumsfeld on the matter: "We're digging pieces of rusted scrap metal and compromised ballistic glass that has already been shot up, dropped, busted—picking the best out of this scrap to put on our vehicles to go into combat. We do not have proper armament vehicles to carry with us north." Rumsfeld's response was classic: "As you know, you go to war with the army you have, not the army you might want or wish to have at a later time."[98] The Administration reassured the media that all troops going to Iraq would be equipped with the best armor available. A year and a half later, one in three don't think they are.

I guess you also go to war at the whim of the president and defense secretary you have, not the ones you wish you had.

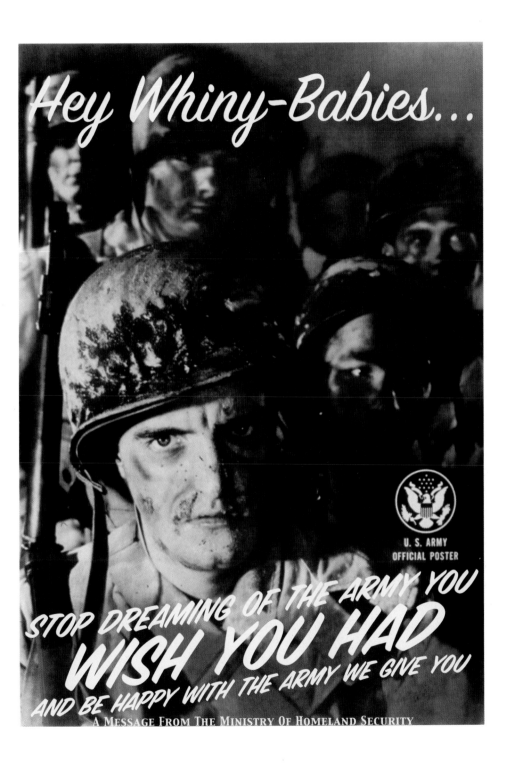

My fellow citizens, not only can we win the war in Iraq,
we are winning the war in Iraq.
—President George W. Bush, December 18, 2005[99]

UNABLE TO CONVINCE ANYONE in the world of his clearly fictitious case for invading Iraq, George W. Bush had nothing like the 500,000 troops that his father's coalition had convened for the Gulf War. Instead, Bush Jr. invaded Iraq with a scant 263,000 U.S. and coalition troops. Though he had a smaller force, Bush Jr. set a much bigger goal for himself: to depose Saddam Hussein and occupy Iraq. In 1991, Bush Sr.'s coalition only desired to push the dictator's troops out of Kuwait and chase them back into Iraq.

At the end of the Gulf War, Bush Sr. recognized the futility of taking over Iraq itself. As he wrote in 1989, "to occupy Iraq would instantly shatter our coalition, turning the whole Arab world against us, and make a broken tyrant into a latter-day Arab hero."[100] It was also reasoned by most experts that to depose Saddam would allow his biggest enemy, Iran, to expand its influence across the region. Oh, for the days when Republicans looked at the Middle East using realpolitik instead of rose-colored neoconservative fantasy goggles.

Back when Bush projected his invasion to be a frolic through flower-strewn streets full of adulatory natives eagerly converting to Western-style democracy, 263,000 troops still seemed rather low. Four years into a guerilla war, however, 263,000 seems insane . . . but we don't have that many there any longer. No, instead we have a paltry 149,000 coalition troops in Iraq.

For a little perspective, reflect on the fact that Iraq is roughly the size of California with a population of 27 million, versus California's 37 million. California has about 200,000 law enforcement officials on the federal, state and local level. The decision to occupy a hostile country the size of California with 50,000 fewer soldiers than California has cops was ludicrous and destined to failure.

The only question now is "how can we blame that failure on the Democrats?"

"There are some who feel like that the conditions are such that they can attack us there...

MY ANSWER IS BRING 'EM ON!"

-George W. Bush - July 2, 2003

THEY BROUGHT IT ON

CONGRATULATIONS MR. PRESIDENT!
Yet another funeral you can skip.
2600 and counting.

KEEP PRETENDING NO ONE'S DYING

THE AMERICAN HERITAGE DICTIONARY defines liberalism thusly: "political theory founded on the natural goodness of humans and the autonomy of the individual and favoring civil and political liberties, government by law with the consent of the governed, and protection from arbitrary authority." Wait . . . where's the part about being evil?

Right-Wing Christians love to demonize "bleeding heart liberals," but they seem to have forgotten where the image of the bleeding heart comes from: the Catholic image of Jesus Christ's sacred heart, on fire, pierced by a crown of thorns and bleeding for mankind. Leave it to conservatives to turn an image of love and blessing into a slur.

The love of money is the root of all evil, said Jesus. Yet Regressive Republicans favor the wealthy and ignore the poor. They lower taxes on the rich. They call themselves "pro-life," but all they care about is ending abortion. Jesus was a pacifist who advised us to pray for our enemies and to turn the other cheek. We've seen how much the president follows that advice. Jesus cast the money-changers out of the temple. Today's right-wing mega-churches have made moneymaking a key element of their purpose.

Jesus stood with the outcast of society: the poor, the oppressed, prostitutes, adulterers, women, and minorities. He *loved* sinners. At every turn he defied the powerful and orthodox, and they killed him for it.

Read the Sermon on the Mount sometime soon. It's practically the liberal party platform: take care of poor people, treat the people near you with kindness, help the homeless, feed the hungry, be merciful, don't start wars, turn the other cheek, do unto others as you would have them do unto you. You know, all that godless liberal stuff.

Isn't it odd that we never hear demands from right-wingers to hang copies of the Sermon on the Mount in courtrooms or in Congress?

Instead of immersing themselves in "an eye for an eye" and "vengeance is mine," the so-called Christians of the religious right would do well to read the second half of the Bible sometime and re-examine just which side of today's politics that Jesus, the forgiving and nurturing aspect of God, would come down on today.

THEY PRAY FOR A WORLD...

Where the rich aren't taxed and *gays can't get married!*

Remember: Jesus Hated Gays, Loved Rich People, and Thought War Was Great!

A MESSAGE FROM THE MINISTRY OF HOMELAND SECURITY

IT'S HARD TO REALLY wrap your head around this one, but stick with it and everything becomes clear. Five thousand years ago, an invisible superhero came down from the heavens and laid out some rules about how the Jewish tribal people were supposed to live. This old book of Jewish folklore is the literal word of God, completely untouched or edited by mankind's hands, and we should rearrange everything in the world to conform to the rules therein, no matter who's made miserable by them. Otherwise our invisible super-friend won't come down and fight Osama Bin Laden's invisible super-friend on our behalf. There, *now* is everything clear?

The president understands that the holy covenant of marriage was created by God expressly for the purpose of the perpetuation of humanity. That's why he also wants to ban marriage for sterile couples and elderly couples past child-bearing age. Oh, wait—sorry, he doesn't want to do that. But he does understand that "The Gays" are really bad parents. He knows this because the Bible says it's true, right there in Leviticus near the section that tells us not to eat weasels, alligators, or owls; not to cut our sideburns, get tattoos, or wear clothes made from two different types of fabrica—and tells us which of our neighbors we can enslave.

Perhaps another reason that President Bush knows gay adoption is bad is because only fifteen states have anti–gay adoption laws on the books! By shoving anti–gay adoption measures onto the ballots in those other thirty-five states in 2006 and 2008, the president can help his party rally anti-gay voters and achieve more partisan victories through bigotry and bias. Not that he's one to pander for the religious right vote or anything.

Now is everything clear?

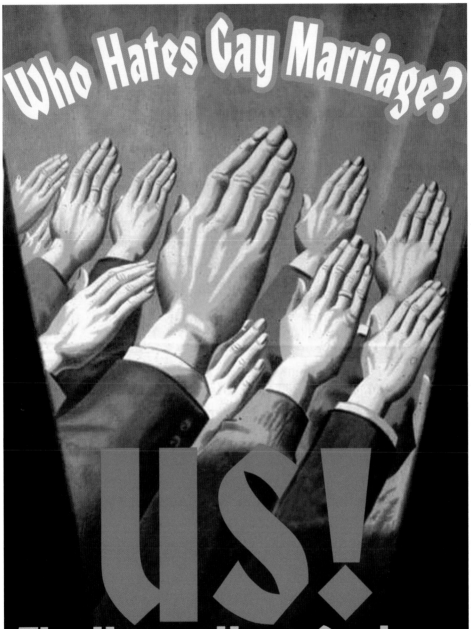

THE BIBLE IS THE INFALLIBLE, literal word of God. It doesn't mention anything about the Theory of Evolution. Therefore, evolution doesn't exist. Fossils were buried in the Earth by Satan to test man's faith in God. We know this because although radiocarbon dating of dinosaur fossils dates them as hundreds of millions of years old, the Bible tells us that the Earth is only 6,000 years old. Surely, God wouldn't lie to us?

For decades, liberals have indoctrinated the lies of Charles Darwin into our children. True, his theory of common descent through natural selection has been the singular unifying scientific theory for all of biology during the last century, but why should we allow the evolutionists with their DNA sequencing and carbon dating to set the educational curriculum for our children? Surely America's politicians and clergy understand science better than those who study it!

Only through the underhanded decisions of "activist judges" were the liberals able to stop teaching our children the truth of Scientific Creationism. Similarly, when scientists who disagreed with Darwin's lies proposed the Theory of Intelligent Design, the evolutionists tarred them with the Creationist brush, when any idiot can see they're not the same thing! Creationists believe that God created all life on Earth. Intelligent Design merely posits that some unknowable, superpowerful Intelligent Designer designed all life on Earth! There's no mention of God in Intelligent Design at all!

Okay, enough comedy. The "debate" about Intelligent Design boils down to this: in science class, do we want our children taught unprovable myths or substantiated scientific facts? There's no credible scientific debate between Evolution and ID, only a scheme by conservative Republicans to politicize the science of biology and use it as yet another wedge-issue with which they can herd their religious voters to the polls. This scheme is abetted by generally poor scientific education standards, and by the modern corporate media which values "balance" over all else, requiring them to present "opposing views," even if those views are matters of faith and lack comparative scientific merit.

This urge to present everyone's ideas as equal is exploited by Republicans like President Bush, who on this issue said, "I think that part of education is to expose people to different schools of thought . . . you're asking me whether or not people ought to be exposed to different ideas, the answer is yes."

However, America's adults may be much harder to teach than our children: a majority of voting-age Americans don't agree that humans developed from earlier species of animals, this despite the fact that humans and chimps share 99 per cent of their genes. Maybe Darwin was wrong . . . many Americans seem not to have evolved at all.

PRESIDENT BUSH BELIEVES in the sanctity of the life of the unborn. Once a child is born, of course, the Bush administration couldn't care less.

So deep is President Bush's commitment to the rights of pre-born Americans that he includes among their ranks fifty-celled pre-embryos created in fertility clinics for the purposes of artificial insemination. This is why the president used his first-ever veto of a Congressional bill on July 19, 2006, to stop a bipartisan attempt to federally fund stem cell research, which destroys embryos to harvest their stem cells.[101] Congress's purported intent was to cure illnesses such as cancer, Parkinson's disease, spinal cord injuries, and many other maladies, but Bush wasn't hoodwinked—he knew Congress just wanted to murder unborn babies!

Having a child via in-vitro fertilization inevitably creates more embryos than are eventually implanted in the mother. Each day, thousands of these surplus embryos are either frozen or "disposed of" by fertility clinics. Bush supposedly considers destroying these embryos to be murder, but he has never once moved to outlaw in-vitro fertilization . . . because he knows this would be political suicide.

The glaring question that faces opponents of stem-cell research now is a simple one: since they won't stop the routine destruction of hundreds of thousands of castoff in-vitro embryos, then how can they morally oppose using those same embryos for the betterment of mankind as a whole? Shouldn't the "sacrifice" of these embryos count for something? Shouldn't their loss help save other lives? Many people would consider healing the living to be a pro-life goal, but sadly, as we've discussed, the president and his adherents are pro-birth, not pro-life, and there *is* a difference.

In 2002, 400,000 of these castoff in-vitro embryos sat frozen in fertility clinics across the United States.[102] Today, that number might be close to a million. Each day that passes, the odds grow slimmer that those embryos will ever be implanted, leaving destruction as their only option. There is a non-conflicting ethical stance which Bush could still take: that there is a difference between embryos created by scientists with the sole goal of destroying them to harvest their stem cells, and surplus embryos created to help infertile parents produce life. Since President Bush refuses to stop the creation of the latter, then he should allow the usage of the former and stop stifling important scientific progress just to pander politically to his base.

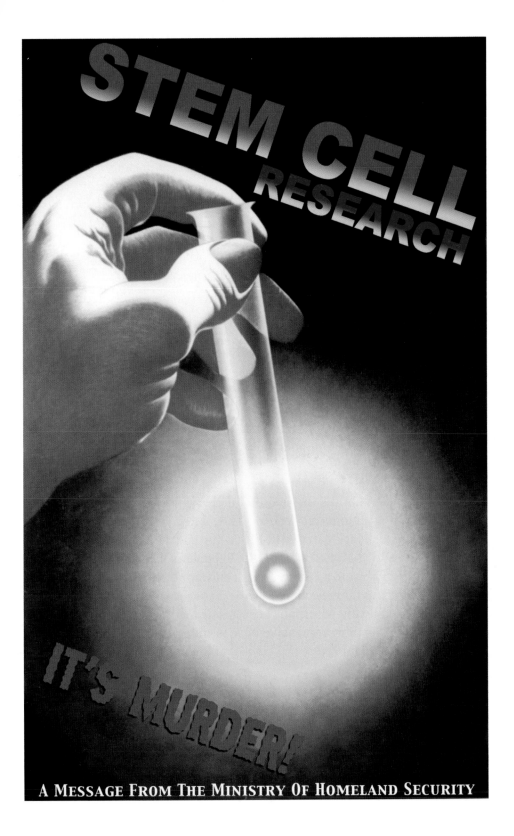

FROM BIRTH TO DEATH, George Bush and his allies will be there to hold your hand and make your decisions for you. Isn't that comforting?

Here's an excellent example of what they have in store for you: in 1990, twenty-six-year-old Theresa Marie "Terri" Schiavo suffered respiratory failure and cardiac arrest. She remained comatose for ten weeks. Three years later, she was diagnosed as being in a persistent vegetative state (PVS) which would last as long as she was kept alive by artificial means. Five years later after that, Terri's husband, Michael Schiavo, filed to have her gastric feeding tube removed. Convinced that Terri was not in a PVS and recovery was still possible, her parents, Mary and Robert Schindler, fought to keep Terri alive. As the case wound its way through the Florida courts, it gained attention from pro-life groups who rallied to Terri's parents' aid, their most loyal legislators close at hand, eager to intrude on this private matter.

The country watched with horror at the ugly spectacle which resulted: wave after wave of motions, hearings, petitions, appeals, and legislative trickery involving President Bush, Senators Bill Frist and Rick Santorum, and House Majority Leader Tom DeLay. Not to mention four denials of certiorari by the Supreme Court of the United States.

During this grisly public fight over the rights of a brain-damaged woman to die with dignity, Republicans insisted that their fight was entirely about the immorality of killing an innocent woman. Then a Republican memo surfaced from the offices of Sen. Mel Martinez (R-FL) stating that the Schiavo case offered "a great political issue" that would "excite" the Republican base and could be used against Senator Bill Nelson, a Florida Democrat who voted against the bill and who would soon be up for reelection.[103]

The idea that right-wing politicians kept this woman medically alive so they could grandstand for their regressive base is indeed pro-life, but it's very pro–*quantity* of life, and not very pro–*quality* of life, if you consider such trivialities to be important.

SECTION SIX: THE WAR ON PROSPERITY

BUSH'S INVASION OF IRAQ had its roots in the neoconservative think-tank Project for a New American Century. PNAC had been agitating for an invasion of Iraq since 1997, seeing a liberated Iraq as a launching pad for invasions of Iran and Syria and the remaking of the entire Middle East in a Western democratic fashion. Several key PNAC figures came to work in the White House after Bush was "elected" in 2000, including, among others, Dick Cheney, Donald Rumsfeld, Paul Wolfowitz, John Bolton, Karl Rove, and Irv Lewis "Scooter" Libby.[104]

Of these, Dick Cheney stood to personally gain the most from a war with Iraq. As secretary of defense under George H. W. Bush III, Cheney pushed through a plan to privatize most of the Pentagon's logistics and support services. In 1992, he awarded fledgling contractor Halliburton with the first such contract. In 1995, Cheney became CEO of Halliburton, taking with him his Pentagon rolodex and military contacts. Over the next five years, Halliburton's military contracts business doubled. Cheney's long-term vision of turning military services over to the private sector has borne fruit; in 2005 over $150 billion dollars in public money was transferred from the Pentagon to private contractors, including a $2 billion no-bid contract to Halliburton to restore Iraq's oil infrastructure.[105]

Before becoming vice president, Cheney was granted a farewell gift from Halliburton of $26.4 million in salary, bonuses, and deferred compensation. When he assumed the vice presidency, Cheney said he had no ties to Halliburton.[106] However, according to his 2001 financial disclosure report, his Halliburton benefits included three batches of stock options comprising 433,333 shares. Adjusted for a stock split in July 2006, that's 866,666 shares. At August 2006's share price of about $34 per share, that's almost $30,000,000 dollars in stock value.[107]

Haliburton's stock has gone up 250 percent since Cheney took over the company in 1995, 140 percent since 9/11 and 82 percent since the beginning of the war in Iraq. Stock analysts currently forecast the stock to go up another 27 percent this next year alone. By that time Cheney's stock will be worth $40,000,000 and climbing. Lord only knows how much it'll be worth by the time we declare war on Iran.

shouldn't Halliburton profit from the War in Iraq?

After all...
We're The Ones Who Started It!

A MESSAGE FROM THE MINISTRY OF HOMELAND SECURITY

IN ORDER TO HIDE THE COST of his Iraq war, George Bush has paid for it via off-budgeted "supplemental appropriations." CostOfWar.com estimates the portion of these appropriations dedicated to the Iraq war at $318.5 billion. Factoring in estimated 2007 supplementals, we're at roughly $360 billion total. (Remember, the White House fired their chief budget guy in 2002 for daring to estimate to Congress that this war might cost between $100 and $200 billion.[108])

To make things worse, Congress also gave the Pentagon permission to transfer funds from other operations, such as the occupation of Afghanistan or routine peacetime expenses. We'll never know how much they spent because they haven't kept track. Yeah, it was probably a bad idea to give carte blanche to an agency that doesn't use modern accounting methods to keep track of its money.[109]

So how big of a magic slush-money fund is available to shift to Iraq's secret budget? Pretty big. During Bush's presidency, the Pentagon budget has swollen like a blood-filled tick. The official yearly American outlay for the Pentagon was $271 billion in 1999. For 2007, the number is about $520 billion, a 91 percent increase.[110] Then if we assume the military *only* diverts 10 percent of its general budget into Iraq, over the four years of the war that means another $200 billion. So, combined with the supplemental appropriations, that's a terrifying total of $560 billion spent on four years of Bush's war, which makes it more expensive than the decade-long Vietnam War.[111]

Meanwhile, the U.S. military budget is almost fifteen times larger than that of China, the second largest spender. The six "rogue states" we may someday fight (Cuba, Iran, Libya, North Korea, Sudan, and Syria) spend $14.65 billion per year combined . . . or 1/30th of what we spend.[112] What a buncha wimps! Those six suckers plus Russia plus China together only spend $139 billion a year, barely 30 percent of the U.S. military budget. And guess who pays for all that crazy out-of-control war spending? Why, YOU do. And your kids. And your grandkids. Yes, you and yours will be paying for Bush's war for some time to come. And while Bush transferred trillions of your tax dollars to defense contractors, he also cut their taxes . . . thus transferring even MORE of your tax dollars into their pockets. Ain't life grand?

Oh, and if you're one of those who say "we need to increase our defense spending to be safer," you're wrong. Tens of billions in Bush's budgets were wasted on programs that will never fight a single Al Qaeda suicider: Virginia Class nuclear submarines, F-22A stealth fighters, the CVN 21 aircraft carrier, and a missile defense system that can't even shoot down a missile with a homing beacon attached to it (which, incidentally, the Iranians and North Koreans aren't going to be nice enough to provide).[113]

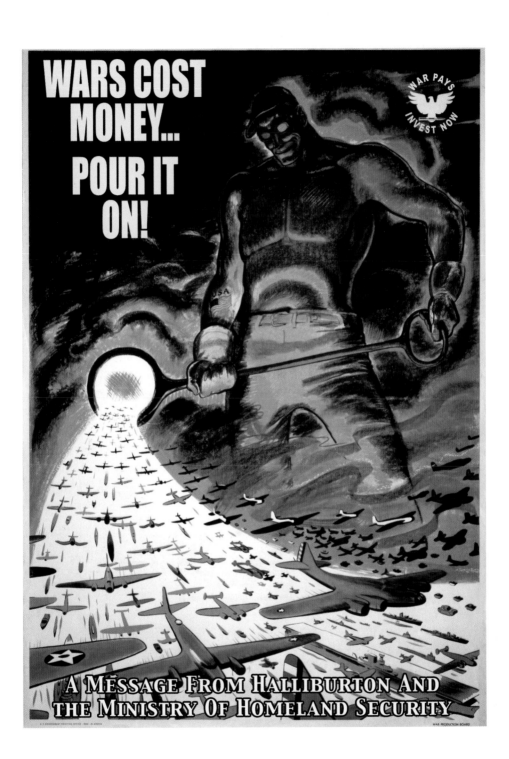

REMEMBER TWO PAGES BACK when we did some fun math and guesstimated Bush's war to have cost America's taxpayers at over half a trillion dollars? Guess what? It gets worse! In January 2006, a comprehensive study by a Nobel Prize–winning economist looked at increased defense spending, payments on federal debt generated by the war, the depreciation of military hardware and the lifetime care required by thousands of returning veterans with post-traumatic stress disorders, amputations, and IED-caused brain traumas. His number? $2.5 trillion over 10 years.[114] Other prize-winning economists have estimated it from $800 billion to $1.25 trillion . . . spent on what, exactly?

You know, instead of fighting this stupid war, why didn't we just make Saddam an offer he couldn't refuse? Pay him $25 billion to step down and give Halliburton the other $75 billion to fix all the damage Saddam's regime and U.N. sanctions had done to Iraq? Sure, it would have meant rewarding an evil dictator (and Saddam Hussein would have profited, also), but would it have been more immoral than this stupid war? 2,600 American soldiers and between 40,000 and 200,000 Iraqis would still be alive, we'd be easing Iraq's transition to democracy much more smoothly, Iraq wouldn't be a training ground for Al Qaeda, and we'd STILL have all the goddamned oil.

Am I the only one who thinks that would have worked?

TAX CUTS...OR WAR?

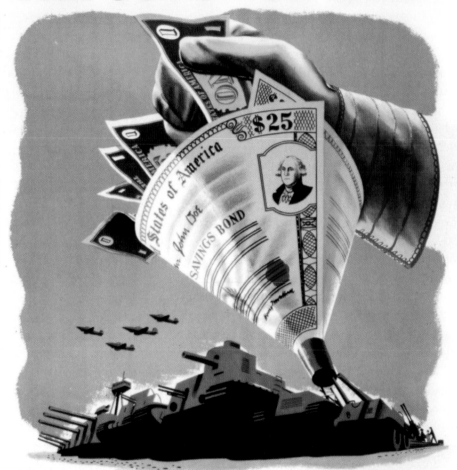

HOW ABOUT BOTH?

FEED THE MACHINE!

A MESSAGE FROM THE MINISTRY OF HOMELAND SECURITY

I HOPE THIS WAR ISN'T ABOUT "Blood for Oil," because if it is, then we're getting royally ripped off.

Back in 1973, when the OPEC countries started an embargo against America, the inflation-adjusted price of gas was $1.45/gallon in today's dollars.[115] At the peak of the Iran-Iraq war in March of 1981, gas hit $2.75/gallon. When Iraq invaded Kuwait, gas soared to $1.90/gallon. After 9/11, gas was $1.75/gallon. On August 13, 2006, gas hit $3.05/gallon. So when Republican spinmeisters tell you that "adjusted for inflation, gas is the same price it's always been,"[116] they're just lying. You can tell, because their mouths are open. They'll also tell you that they make the same nine percent in profit whether they sell oil for $50/barrel or $150/barrel. Sure, but 9 percent of $50 oil is only $4.50 versus $13.50 on the $150 oil, both of which cost the exact same to pump and ship. Which barrel would *you* rather sell?

Get used to hearing that $150 per barrel of oil number, too. Especially if the United States attacks Iran using their nuclear weapons programs as a pretext for a unilateral first strike. Worldwide concern about an attack on Iran and the energy supply disruption which would occur is only one of several reasons for high gas prices, but it is the *one* reason absolutely under our control, and it's caused oil and gas to spike dramatically in confluence with Bush's saber-rattling toward Iran.

Any military strike against Iran, even limited to only the nuclear weapons production sites of the country, will raise oil to $150–200 per barrel versus today's already inflated near-record prices of $73 per barrel. Imagine that $12/gallon gas. You know who else is imagining that? ExxonMobil. BP. Shell. Chevron. Saudi Aramco. Guys like that.

Back in 2002, when Dick Cheney and his neocons were leading the propaganda push against Iraq, Dick said that a nuclear-armed Saddam Hussein would "seek domination of the entire Middle East, take control of a great portion of the world's energy supplies, directly threaten America's friends throughout the region and subject the United States or any other nation to nuclear blackmail." Now we hear the same story again, just drop the Q from "Iraq" and add an N.

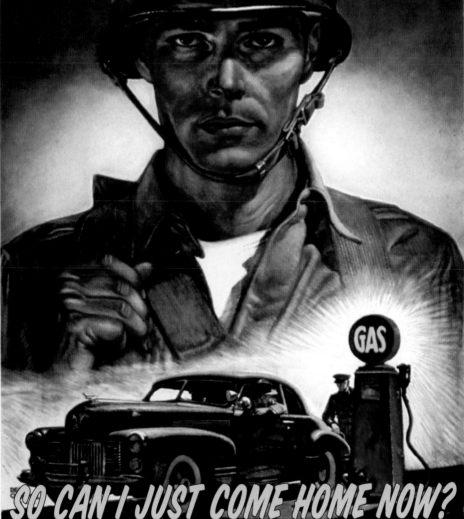

IN 2002, MANY PUNDITS predicted that Iraq would be a pushover and a prelude to the Project for a New American Century's real intentions: war with Iran. After four years of slow guerilla war, however, there's no way you're getting America's citizens back on that horse. At least not until the neoconservatives can convince us otherwise.

Anyone who has been near TV news or visited conservative websites in 2006 has heard the drumbeat for war on Iran. There are some very bad leaders in that country and it would doubtless feel great to topple their repressive fundamentalist regime . . . but as we've seen in Iraq, freeing people at gunpoint doesn't make people love you.

Look at the situation for a moment through Iran's eyes. They are surrounded by hostile nations, some of whom have nuclear weapons already (Israel, Pakistan, and whomever else Pakistan sold nuclear weapons to). Their young have turned against the Islamic Revolution. Now George Bush is making the same noises against you that he made against Iraq before invading . . . *after* Saddam complied with America's demands and proved that he didn't have any nuclear weapons. Why on Earth *wouldn't* you want nuclear weapons? And why, if America demanded you prove you aren't researching them, would you show your hand? If you prove you don't have nukes, then America's immense military might will probably be brought against you under some other pretext in an effort at regime change. Look, America's not even thinking about invading North Korea solely *because* they have nuclear weapons.

For Americans who fear Iran's ability to someday build nuclear weapons (which most experts put at ten years away), they should remember a few things. First, invading or even bombing Iran would make president Mahmoud Ahmadinejad wildly popular, even with the younger people of Iran (just like 9/11 made President Bush more popular in America). Any attack will punch oil and gas prices through the roof as Iran shuts off their supply or America bombs it for Halliburton to rebuild later. Iraqi Shiites who have thus far restricted their violence to Sunnis would turn on American troops. Our attacks would fuel terrorist recruitment and flame anti-Western sentiment among Muslims all over the world. Worse, it would probably cause massive problems with China, which gets 13 percent of its oil from Iran.

If we don't want to dangerously increase tension throughout the Middle East, we need to admit two things: 1) we have no realistic military resolution for the problem of Iran's nuclear program, and 2) we must make diplomacy work.

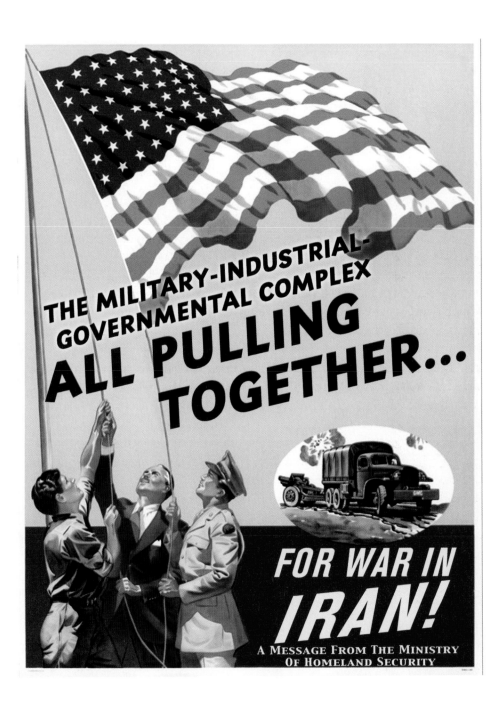

SO, BEFORE THIS INFORMATION disappears down the memory hole,[117] or the firemen come for this book,[118] let's sum up, shall we? Here's an easy nine-step system for destroying the world's oldest democracy:

First, a candidate is nominated for high office. He gathers support from the fringes of his party by playing to the biases of their religious extremists . . .

. . . then he miraculously "wins" an election using fraud[119]. . .

"This new-fangled electronic voting machine is swell!"

IT COUNTS YOUR VOTE BEFORE YOU EVEN PULL THE LEVER!

A MESSAGE FROM THE MINISTRY OF HOMELAND SECURITY

. . . and immediately rewards his extremist allies with victories on their pet issues, thereby increasing their support . . .

. . . support which he then rides into a Holy War against a villain whom he com-
pares to past villains[120]. . .

You know that guy, the one who runs that country we're mad at this week?

Well, He's As Bad As

HITLER!
(no, seriously this time)

We Should Totally Invade His Country
A MESSAGE FROM THE MINISTRY OF HOMELAND SECURITY

. . . which, due to the stand-off nature of modern weaponry, is relatively pain-less to the home country, while killing tons of innocent civilians overseas[121]. . .

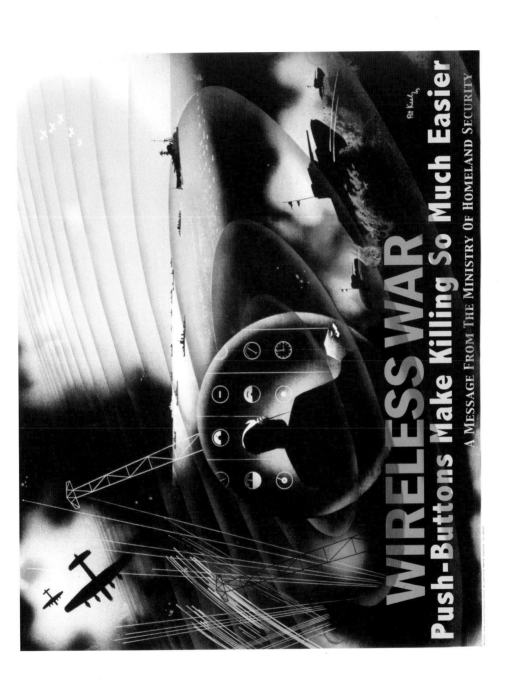

. . . deaths which we hardly ever hear about because the corporate media see far more dollars in reporting news that is "balanced" and "patriotic" rather than news which reflects what's actually going on[122] . . .

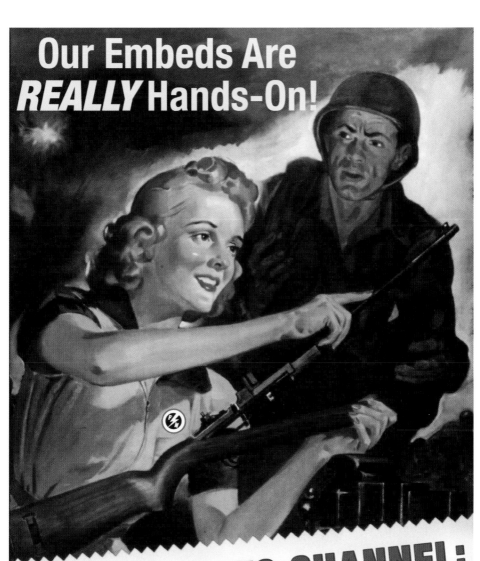

. . . which is why there's been so little public outcry over the fact that the beloved leader has been caught spying on his own people[123]. . .

You Bet We're Listening!

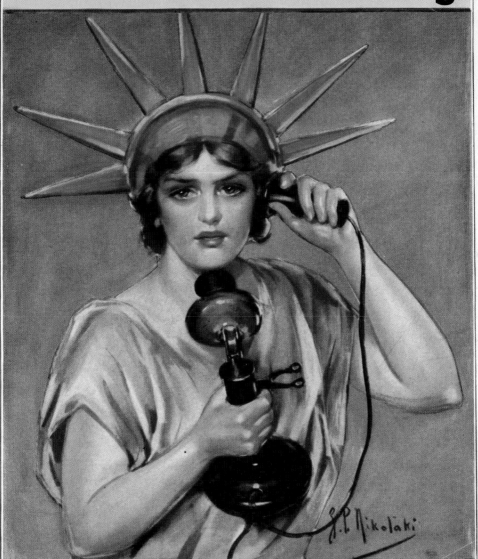

Only Al Qaeda Suiciders
have anything to hide from Lady Liberty!
A MESSAGE FROM THE MINISTRY OF HOMELAND SECURITY

. . . who are going broke due to the crushing debts created by his wars[124]. . .

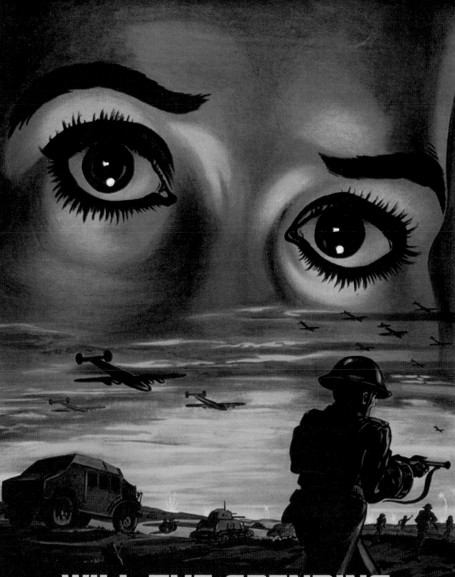

. . . debts which force the country to start more and more wars to keep the artificial cycle of debt flowing. Return to Step One. Lather, Rinse, Repeat.

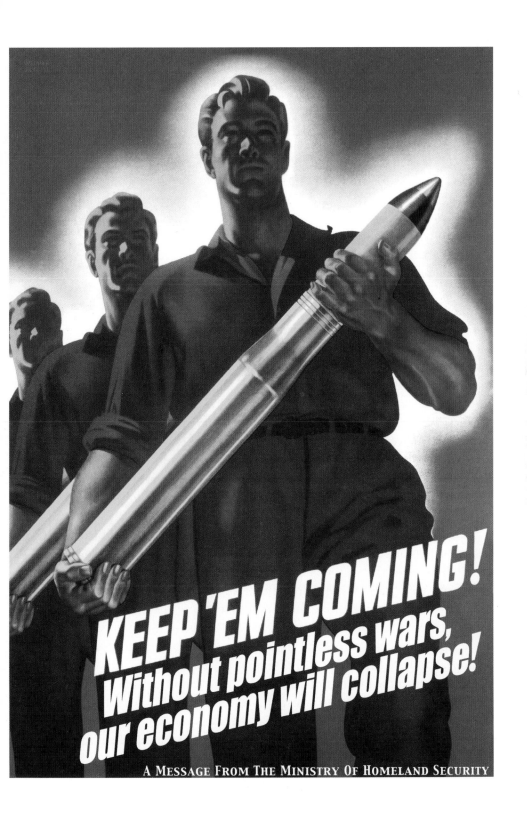

KEEP 'EM COMING!
Without pointless wars, our economy will collapse!

A MESSAGE FROM THE MINISTRY OF HOMELAND SECURITY

Third time I've said that. I'll probably say it three more times. See, in
my line of work you got to keep repeating things over and over and over
again for the truth to sink in, to kind of catapult the propaganda.
—President George W. Bush, May 24, 2005[125]

BOY, HE'S NOT KIDDING: Clear Skies Initiative, the Healthy Forests Initiative, The Death Tax, Social Security Reform, Leave No Child Behind, the USA PATRIOT ACT, Tort Reform, Homeland Security, Compassionate Conservatism, the Consumer Protection Act . . . the list goes on and on and on. Bush's White House website even has a page entitled "Setting The Record Straight" which purports to prove that we're winning in Iraq, Bush's stance on Stem-Cell Research is working, the economy is great for everyone, and nothing bad that happened in the wake of Hurricane Katrina was the White House's fault. Orwell would be horrified—he thought he'd written a dystopian novel, not a how-to manual.

Here's another example: Bush stated that the August 2006 foiled plot to blow up British planes with liquid explosives was a "stark reminder that this nation is at war with Islamic fascists."[126] This statement provides the reader a "stark reminder" that Bush is a propagandist of the highest order. In using the words like "Islamofascist," he seeks to verbally tie his War on Terror to "the good war" of World War II and murderous criminals like Osama Bin Laden to Adolf Hitler.

Mussolini invented Fascism and even coined the word himself. Here's how he described it: "Fascism should more appropriately be called Corporatism because it is a merger of state and corporate power." Last time Bin Laden released one of his cave recordings, he wasn't the one calling for AT&T to merge with the government to spy on its citizens.

In 1995, the philosopher and novelist Umberto Eco posited fourteen eternal indicators of a fascist, in essence they were as follows:[127] (1) obsessive traditionalism—belief that the "truth" has been laid out for us in prior history and if only we regress to a previous time, we shall discover it; (2) rejection of modernism – belief that new thought and learning means nothing; (3) the cult of action for action's sake—a pervasive distrust of the intellectual world; (4) disagreement is treason and must be repressed for the good of the state; (5) appeal against diversity —racist distrust of "the intruders" and "the other"; (6) an appeal to the frustration and anxiety of the middle class; (7) an obsession with Nationalism and a corresponding fixation with "the plot" against the nation, usually international in nature but always with "the enemy within" conspiring against the nation; (8) followers must be made to feel humiliated

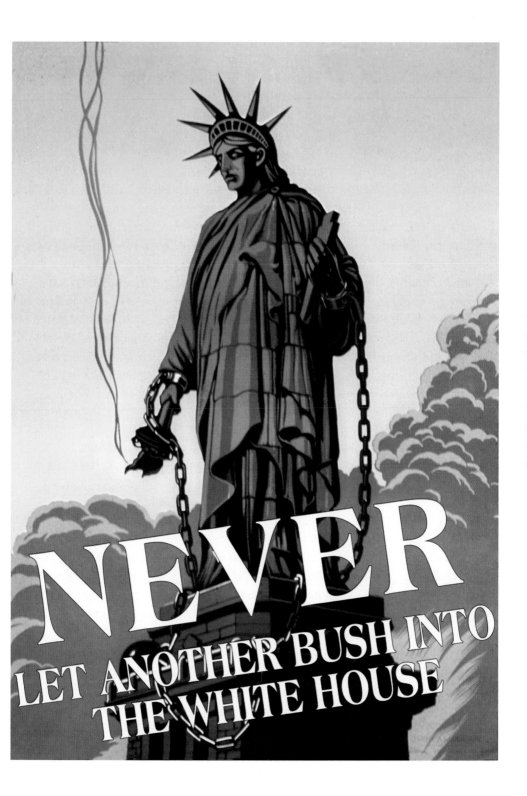

by the power of the enemy and at the same time they must be convinced they can overcome the enemy, by shifting rhetoric the enemies must seem too strong and too weak—"Fascist governments are condemned to lose wars because they are constitutionally incapable of objectively evaluating the force of the enemy"; (9) life is permanent warfare, thus pacifism is weakness—this creates an Armageddon complex, a desire for the "final battle"; (10) a popular elitism—every citizen belongs to the best people in the world, the members or the party are the best among the citizens; (11) the cult of heroism and a longing for heroic death, the best reward for a heroic life—"The Ur-Fascist hero is impatient to die. In his impatience, he more frequently sends other people to death"; (12) an inclination towards machismo—both disdain for women and intolerance and condemnation of nonstandard sexual habits, such as homosexuality; (13) a disdain for popular elections—because The Leader is the Voice of the People and uniquely able to determine their feelings, no other form of government is necessary other than The Leader; (14) Ur-Fascism speaks Newspeak[128]—Newspeak was invented by Orwell in *Nineteen Eighty-Four*, and it consists of a systematic distortion of language consisting of greatly reduced and simplified vocabulary and elementary grammar to make any alternative thinking ("thoughtcrime") or speech impossible by removing any words or possible constructs which describe the ideas of freedom, rebellion, and so on.

Looking over those fourteen characteristics, it's amazing how many can't be applied to Al Qaeda. Should any of this ring alarm bells? Of course not. After all, this is America, a democracy with a constitution, strict adherence to the rule of law, a free press, no official policies of racism against "the other," no homophobia, no pointless wars, fair elections, and a well-informed public constantly exercising their political voice. Right?

America needs to step back from the brink of World War III for a moment and get some perspective about terrorism: in 2001, three times as many Americans suffocated on their food than were killed by the September 11th terrorists. Accidental falls (from ladders, down stairs, off scaffoldings, etc.) killed five times as many Americans as the collapse of the World Trade Center. American drunk drivers killed more than five times as many of their fellow Americans as Osama Bin Laden did in 2001. Ten times as many Americans committed suicide in 2001 as were killed by Mohammed Atta and his flight crew of Islamist fanatics. The 2001 American death toll from smoking alone was 150 times the number of deaths from the terror attacks of September 11th. In the next year, you are more

likely to drown in your own bathtub than to be killed or injured in a terrorist attack. None of this means that Al Qaeda isn't a threat, or that the events of September 11th weren't a horrible tragedy . . . but numbers like these do put into context the attacks of 9/11. Here's another: Bush's war in Iraq has now cost more soldiers their lives than civilians died in 9/11. Here's another: between 40,000 and 200,000 Iraqi civilians have been killed during the same period of time. Numbers like these help us see through the constant stream of paranoia, lies, and propaganda aimed at us by our government and the corporate media. Numbers like these point up the difference between the constant "threat" we're told we're under from "terrorist suiciders" and the reality that statistically, each of us is far more likely to be killed this year by our own spouse than we are to be killed by Osama Bin Laden. Moreover, knowing the reality of these numbers means we can actually adjust our resources and our country's power toward smarter goals. The United Nations estimates that an additional $50 billion a year would end hunger for the one billion people who go without adequate food and clean water each day. Meanwhile, we here in America are due to spend $560 billion on war in 2007. It's priorities like this that make people hate us, not "our freedom."

But never mind all that, we're at war! Why? Because a *war* president has extraordinary, unquestioned powers. Bush declared this war not on a nation, or even a specific group, but upon an idea: "Terror." Not the tactic of terrorism, mind you, but the even vaguer enemy of terror as a concept. Never mind that one might as well declare a War On Sadness or a War On Envy for all the efficacy you'll have in winning such an impossible fight . . . the idea here isn't to "win," but instead merely to "fight" the War on Terror. Why? Because unlike an enemy, a concept can't be killed on the battlefield. The War on Terror can *never* end. There can be no peace treaty with Terror. This war isn't a war, it's a prescription for keeping Bush and his particular theocratic brand of conservatives in power indefinitely.

Does that mean we shouldn't fight terrorism? Of course not. But we do need to understand that it's a criminal fight, a foreign intelligence fight—only in limited scenarios is it a military fight. Terrorism can't be stopped with cruise missiles, tanks, and carpet-bombing, because every time an innocent civilian is killed, it just makes more terrorists. And because no number of aircraft carriers, nuclear attack submarines, or F-22 Raptor stealth fighters can ever kill all of the terrorists, we should probably question why we are spending the vast bulk of our money on military weapons that have little to nothing to do with fighting a small, mobile, unconventional enemy which hides amongst a civilian population.

With my ongoing graphic experiment, The Propaganda Remix Project (http://www.antiwarposters.com), I try to clarify and define the connections between the pleasant slogans this government says and the unpleasant realities of what it does. I want to reach into the viewers mind and yank out the wiring placed there by media repetition. The natural enemy of propaganda is education, and by using facts and the government's propaganda imagery against it, I hope to clarify the connections between the messages we're inundated with and what the facts truly are. I've remixed over 500 posters so far, and so long as our government is engaging in its "newspeak" and "doublethink," I'll probably keep making more. I hope to never have to make another after 2008.

Bush's presidency points the way toward an Orwellian future of endless war, convenient lies, total surveillance, and complete thought and language control. But unlike the doomed lovers of 1984, we still have ways to resist. It's time to speak out and to vote and to send a clear signal to the warmongers: we don't love Big Brother.

Micah Ian Wright
September 7, 2006

NOTES

1. http://www.whitehouse.gov/news/releases/2003/10/20031006-3.html; http://www.whithouse.gov/news/releases/2003/10/20031007-2.html; http://www.whitehouse.gov/news/releases/2006/05/20060523-9.html.
2. "Bush Lets U.S. Spy on Callers Without Courts," *New York Times,* December 16, 2005.
3. http://www.whitehouse.gov/news/releases/2006/05/20060511-1.html
4. "NSA secret database report triggers fierce debate in Washington," *USA Today,* May 11, 2006.
5. "Judge Reverses Convictions in Detroit 'Terrorism' Case," *New York Times,* September 3, 2004.
6. "Bank Data Is Sifted by U.S. in Secret to Block Terror," *New York Times,* June 23, 2006.
7. "Why Bush Approved the Wiretaps," by Byron York, *New Republic Online,* December 19, 2005. See also the rebuttal to the argument; "Surveillance Net Yields Few Suspects—NSA's Hunt for Terrorists Scrutinizes Thousands of Americans, but Most Are Later Cleared," *Washington Post,* February 5, 2006.
8. "FBI Checking Reporters' Phone Records," *Christian Science Monitor,* May 16, 2006.
9. "Legal Authorities Supporting the Activities of the National Security Agency Described by the President," Alberto Gonzales, U.S. Department of Justice, January 12, 2006; available online at: http://news.findlaw.com/hdocs/docs/nsa/dojnsa11906wp.pdf.
10. "Bush Could Bypass New Torture Ban—Waiver Right is Reserved," *Boston Globe,* January 4, 2006.
11. "Legal Authorities Supporting the Activities of the National Security Agency Described by the President."
12. http://en.wikipedia.org/wiki/Big_Brother_%281984%29.
13. "Video Shows Bush Got Explicit Katrina Warning," MSNBC, March 2, 2006.
14. http://www.cnn.com/2004/ALLPOLITICS/04/08/rice.transcript/.
15. "Brown's Turf Wars Sapped FEMA's Strength," *Washington Post,* December 23, 2005.
16. "Bush Cuts Texas Vacation Short to Oversee Hurricane Response," *Washington Post,* August 30, 2005.
17. http://www.whitehouse.gov/news/releases/2005/09/20050912.html
18. http://www.washingtonmonthly.com/archives/individual/2005_09/007023.php.
19. http://www.whitehouse.gov/news/releases/2005/09/20050902-2.html.
20. Ibid.
21. "It's Only $300 Billion," May 10, 2006.
22. http://www.whitehouse.gov/news/releases/2006/01/20060131-10.html.
23. "CIA Official Quits; FBI Probes Role in Defense Contracts," *Washington Post,* May 9, 2006.
24. "Halliburton Subsidiary KBR Awarded Homeland Security Contract Worth Up To $385M," *Marketwatch,* January 24, 2006.
25. "Halliburton Subsidiary Gets Contract to Add Temporary Immigration Detention Centers" by Rachel L. Swarns, *New York Times,* February 4, 2006.
26. "Friends in the White House Come to Coal's Aid," August 2, 2004.
27. "Under Mined" by Clara Bingham, *Washington Monthly,* February 2005. "Coal's Power Over Politicians," *New York Times,* January 6, 2006. "A Toxic Cover-Up? Did Bush Administration Cover Up Environmental Disaster?" CBS News, October 4, 2004. "A Polluter's Feast—Bush Has Reversed More Environmental Progress in the Past Eight Months than Reagan Did in a Full Eight Years," *Rolling Stone,* October 8, 2005.
28. "Sago Mine Violations and Citations," *Boston Globe,* January 7, 2006.
29. "The Bush Global Gag Rule: Endangering Women's Health, Free Speech and Democracy," Center for Reproductive Rights website: http://www.crlp.org/.
30. See: http://www.thousandreasons.org/reasons.php for news source links on these events.
31. "Memo May Have Swayed Plan B Ruling," *Newsday,* April 27, 2006, which includes this choice quote: In the memo released by the FDA, Dr. Curtis Rosebraugh, an agency medical officer, wrote: *"As an example, she [Woodcock] stated that we could not anticipate, or prevent extreme promiscuous behaviors such as the medication taking on an 'urban legend' status that would lead adolescents to form sex-based cults centered around the use of Plan B."* Yep. Teenaged sex-based cults.

32. "Over-the-Counter Insurgency," *Mother Jones*, August 2006.
33. "Thirty Years After *Roe vs. Wade*, American Support Is Conditional," ABC News, January 2003.
34. http://www.guttmacher.org/in-the-know/index.html.
35. "Thousands Protest Bush's Inauguration," Salon.com, January 20, 2001.
36. "Free-Speech Zone," *American Conservative*, December 15, 2003.
37. "2005 Presidential Inauguration—National Special Security Event," Department of Homeland Security.
38. "Donors Get Good Seats, Great Access this Week," *USA Today*, January 16, 2005.
39. http://www.whitehouse.gov/news/releases/2005/08/20050829-11.html.
40. "More Than One-Third of Louisana National Guard Deployed In Iraq And Elsewhere," Cox News Services, August 30, 2005.
41. "More Active, Guard Troops Join Katrina Response," Armed Forces News Services, August 30, 2005.
42. "New Orleans District of the U.S. Army Corps of Engineers Faces Cuts," New Orleans City Business, June 6, 2005.
43. "New Orleans Is Sinking," *Houston Chronicle*, December 1, 2001.
44. "Shifting Federal Budget Erodes Protection from Levees; Because of Cuts, Hurricane Risk Grows," *New Orleans Times-Picayune*, June 8, 2004.
45. "Bush's War On The Press," *The Nation*, May 9, 2005.
46. "The End of Chávez—History's Against Him" by Francis Fukuyama, *Washington Post*, August 6, 2006.
47. "U.S. Accused of Bid to Oust Chávez with Secret Funds," *The Guardian*, August 30, 2006.
48. "Researchers Who Rushed Into Print a Study of Iraqi Civilian Deaths Now Wonder Why It Was Ignored," *Chronicle of Higher Education*, January 27, 2005.
49. "Mortality Before and After the 2003 Invasion of Iraq: Cluster Sample Survey," *The Lancet*, December 2004.
50. "War Without End" by Robert Fisk, *The Independent*, January 2, 2006.
51. "State Department Contractors Kill 2 Civilians in N. Iraq," *Washington Post*, February 9, 2006.
52. "Immunity Provision Extended for U.S. Firms With Reconstruction Contracts," *Washington Post*, June 29, 2004.
53. "Torture at Abu Ghraib," *The New Yorker*, May 10, 2004.
54. "Marines Jail Contractors in Iraq—Tension and Confusion Grow Amid the 'Fog of War'," CorpWatch, June 7, 2005.
55. *Gherebi v. Bush*, Ninth Circuit, December 18, 2003. To quote the judge: "Indeed, at oral argument, the government advised us that its position would be the same even if the claims were that it was engaging in acts of torture or that it was summarily executing the detainees." http://caselaw.lp.findlaw.com/data2/circs/9th/0355785p.pdf.
56. "Afghanistan to Guantánamo Bay—the Story of Three Released British Detainees," *The Guardian*, August 4, 2004.
57. "Guantánamo Bay—Detainees," GlobalSecurity.org.
58. "Who Is At Guantanamo Bay" by Corine Hegland, *National Journal*, February 3, 2006.
59. "Saudi Detainees Released From Guantánamo Bay Detention," Associated Press, May 18, 2006.
60. "Nevermind, Hamdi Wasn't So Bad After All" by Dahlia Lithick, Slate.com, September 23, 2004.
61. "European Probe Finds Signs of CIA-Run Secret Prisons," *Washington Post*, June 8, 2006.
62. "CIA's Harsh Interrogation Techniques Described," ABC News, December 8, 2005.
63. "Night-and-Fog Decree (Nacht-und-Nebel Erlass)," SS Reichsführer Himmler, Nazi Germany—Office of United States Chief of Counsel for Prosecution of Axis Criminality, Nazi Conspiracy and Aggression—see also: http://www.historyplace.com/worldwar2/timeline/nacht2.htm and http://www.yale.edu/lawweb/avalon/imt/nightfog.htm
64. "Secrecy Privilege Invoked in Fighting Ex-Detainee's Lawsuit," *Washington Post*, May 13, 2006.
65. http://www.whitehouse.gov/news/releases/2001/11/20011113-27.html.
66 *Hamdan v. Rumsfeld, Secretary of Defense*, Supreme Court of the United States, October 2005.
67. http://www.whitehouse.gov/news/releases/2006/07/20060707-1.html.
68. "White House Proposal Would Expand Authority of Military Courts" *Washington Post*, August 6, 2006.
69. http://en.wikipedia.org/wiki/2%2B2%3D5.
70. http://www.pollingreport.com/iraq.htm
71. "UN inspectors begin Iraq mission," BBC News, November 8, 2002.
72. "Timeline, the Road to War in Iraq," *The Guardian*, February 2, 2006; "U.S advises weapons inspectors to leave Iraq," *USA Today*, March 17, 2003.

73. http://www.whitehouse.gov/news/releases/2003/07/20030714-3.html.

74. http://www.whitehouse.gov/news/releases/2004/01/20040127-3.html; http://www.whitehouse.gov/news/releases/2006/03/20060321-4.html.

75. http://www.whitehouse.gov/news/releases/2006/05/20060527-1.html.

76. "Half of U.S. Still Believes Iraq Had WMD" Associated Press, August 6, 2006.

77. "Comprehensive Report of the Special Advisor to the DCI on Iraq's WMD," a.k.a. "Duelfer Report" available at: https://www.cia.gov/cia/reports/iraq_wmd_2004/chap1.html.

78. http://mediamatters.org/items/200607220002.

79. "Thousands of Troops Say They Won't Fight," Gannett News Services, August 5, 2006.

80. "Army Likely to Fall Short in Recruiting, General Says" New York Times, July 23, 2005

81. http://www.whitehouse.gov/news/releases/2001/09/20010914-5.html.

82. "Army Forces 50,000 Soldiers into Extended Duty," Reuters, January 29, 2006.

83. "Army Raises Enlistment Age To 42," Army News Services, June 22, 2006.

84. "Army moves to recruit more high school dropouts," Knight-Ridder Newspapers, October 3, 2005.

85. "GI Schmo, How Low Can Army Recruiters Go?" by Fred Kaplan, Slate.com, January 9, 2006. See also: "Army Recruitment of Autistic Teen Raises Questions," ABC News, May 12, 2006.

86. "Determinants of Productivity for Military Personnel," Rand Corporation Study on behalf of the Pentagon, 2005.

87. "Pentagon Alerted to Trouble in Ranks," Los Angeles Times, July 1, 2004; "Out of Jail, Into the Army," Salon.com, February 2, 2006.

88. "Accused GI Was Troubled Long Before Iraq," New York Times, July 14, 2006.

89. "Hate Groups Are Infiltrating the Military, Group Asserts," New York Times, July 7, 2006.

90. "A Few Bad Men," Southern Poverty Law Center, SPLCenter.org, July 2006.

91. "Policy Concerning Homosexuality in the Armed Forces," U.S. Legal Code, Title 10 > Subtitle A > Part II > Chapter 37 > § 654.

92. "Email Rumours Forced Gay Sergeant Out of US Army," The Guardian, July 28, 2006.

93. "Army Dismisses Gay Arabic Linguist" CNN, July 27, 2006.

94. "Financial Analysis of 'Dont Ask, Don't Tell': How Much Does the Gay Ban Cost?" Panel Report, University of California, Santa Barbara, January 2006.

95. "Stop Hunting Gay Troops," Legal Times, February 2005.

96. "Don't Ask, Don't Tell Facts," Military Education Initiative & Service Members Legal Defense Network.

97. All poll numbers from Zogby International, poll and methods available online: http://www.zogby.com/news/ReadNews.dbm?ID=1075

98. Rumsfeld Gets Earful From Troops; Complaints Cite Equipment Woes, Extended Tours and Pay Delays," Washington Post, December 9, 2004.

99. http://www.whitehouse.gov/news/releases/2005/12/20051218-2.html.

100. "A World Transformed" by George H.W. Bush III and Brent Scowcroft, Alfred A. Knopf, 1998.

101. "Stem Cell Bill Gets Bush's First Veto," Washington Post, July 20, 2006.

102. "Souls On Ice: America's Human Embryo Glut," Mother Jones, July/August 2006.

103. "Dissecting a Right-wing Smear: How Conservatives Used Trumped-up Evidence to Blame Democrats for Schiavo Memo," Media Matters For America, available at: http://mediamatters.org/items/200504070005

104. "The Project for a New American Empire: Who Are these Guys? And Why Do They Think They Can Rule the World?" Sojourner Magazine, September/October 2003.

105. "Claim vs. Fact: Cheney, Halliburton & the Government," Center for American Progress, January 23, 2004.

106. "Cheney's Halliburton Ties Remain: Contrary To Veep's Claims, Researchers Say Financial Links Remain," CBS News, September 26, 2003.

107. All stock prices and calculations completed using Yahoo Finance.

108. "West Wing Loyalty: A Fine Line," Christian Science Monitor, December 17, 2002.

109. "Adopt Best Business Practices to Modernize the Pentagon's Accounting System," Business Executives for National Security, October 2004.

110. "Department of Defense: Focusing On The Nation's Priorities," Office Of Management and Budget, 2006.

111. "More costly than 'the war to end all wars'," *Christian Science Monitor*, August 29, 2005.

112. "U.S. Military Spending Versus Rest of the World," Center for Arms Control and Proliferation; http://www.armscontrolcenter.org/archives/002244.php.

113. "Whose Missile Shield Is It, Anyway? Now We're Talking About Putting Expensive, Useless Interceptors in Europe" by Fred Kaplan, Slate.com, May 23, 2006.

114. "Iraq sticker shock," Salon.com, January 11, 2006.

115. Historical gas prices obtained from: http://www.massachusettsgasprices.com/retail_price_chart.aspx

116. "Historically, Gasoline Prices Are Not Expensive," CATO Institute, September 6, 2003.

117. http://en.wikipedia.org/wiki/Memory_hole.

118. http://en.wikipedia.org/wiki/Fahrenheit_451.

119. "Was the 2004 Election Stolen?" by Robert F. Kennedy, *Rolling Stone*, June 2006.

120. In the future, everyone will be Hitler for 15 Minutes! For proof, see: "Condi's Phony History" by Daniel Benjamin, Slate.com, August 29, 2003; http://www.whitehouse.gov/news/releases/2004/05/20040529.html; http://www.defenselink.mil/transcripts/2003/t04012003_t0401sd.html; "Rumsfeld Compares Chavez To Hitler," Associated Press, February 3, 2006; "Comparing Saddam to Hitler is Justified" by Jonah Goldberg, Townhall.com, February 19, 2003; "Santorum Compares Democrats, Hitler," *Pittsburgh Post-Gazette*, May 24, 2005; "In Ft. Bragg Speech, Rumsfeld Compares Zarqawi to Hitler," May 26, 2005.

121. "Joystick vs. Jihad: The Temptation of Remote-controlled Killing" by William Saletan, February 4, 2006.

122. "The Problem of the Media: U.S. Communications Politics in the 21st Century" by Robert W. McChesney, *Monthly Review Press*, 2004.

123. "Sixty-four percent (64%) of Americans believe the National Security Agency (NSA) should be allowed to intercept telephone conversations between terrorism suspects in other countries and people living in the United States," Rassmussen Poll, December 28, 2005.

124. "Left Behind Economics" by Paul Krugman, *New York Times*, July 14, 2006.

125. http://www.whitehouse.gov/news/releases/2005/05/20050524-3.html.

126. "Bush seeks political gains from foiled plot," AFP Newswire, August 11, 2006.

127. "Eternal Fascism: Fourteen Ways of Looking at a Blackshirt" by Umberto Eco, *New York Review of Books*, June 22, 1995.

128. http://en.wikipedia.org/wiki/Newspeak

 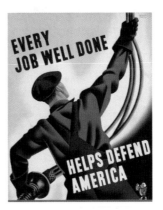

PAGE 11
Weimer Pursell, USA, 1944

PAGE 13
Weimer Pursell, USA, 1944

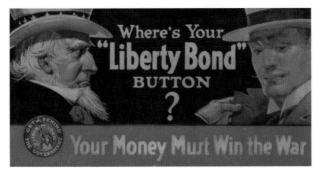

PAGE 15
C. R. MacCauly, USA, 1917

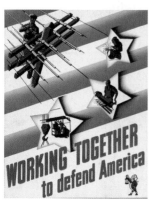

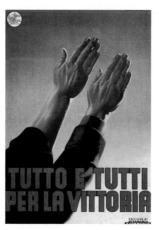

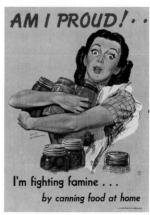

PAGE 17
Weimer Pursell, USA, 1944

PAGE 19
Luigi Martinati, Italy, 1944
"All and Everyone for Victory"

PAGE 21
Dick Williams, USA, 1946

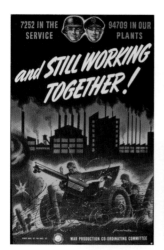

PAGE 23
J. Howard Miller,
USA, 1943

PAGE 25
Dux Alexander, USA, 1939

PAGE 27
Peter Ewart, Canada, 1950

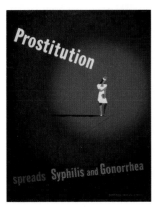

PAGE 29
Leonard Karsakov, USA, 1942

PAGE 31
Morris Katz, USA

PAGE 33
Norman Rockwell, USA

PAGE 35
Harry Anderson, USA, 1942

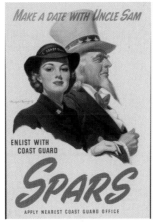

PAGE 37
Bradshaw Crandell, USA, 1943

PAGE 39
Uncredited, USA, 1943

PAGE 41

Rico Tomaso, USA, 1942

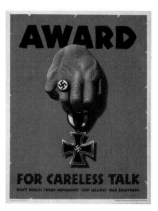

PAGE 43

Stevan Dohanos, USA, 1943

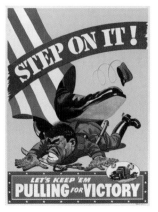

PAGE 45

Uncredited, USA, 1944

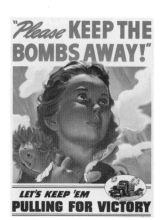

PAGE 47

Uncredited, USA, 1942

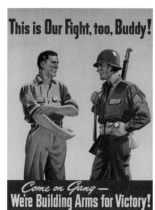

PAGE 49

Uncredited, USA, 1942

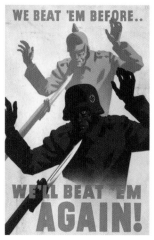

PAGE 51

Uncredited, UK, 1940

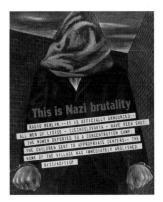

PAGE 53
Ben Shahn, USA, 1942

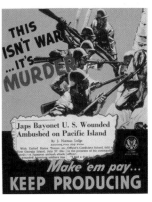

PAGE 55
Uncredited, USA, 1944

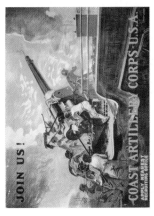

PAGE 57
Philip Lyford, USA, 1920

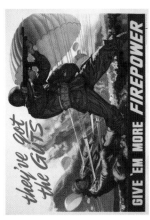

PAGE 59
Dean Cornwell, USA, 1943

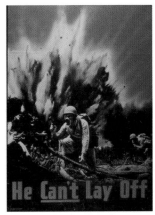

PAGE 61
Uncredited, USA, 1945

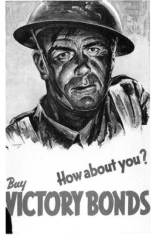

PAGE 63
Joseph Ernest Sampson,
Canada, 1942

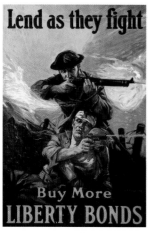

PAGE 65
Sidney Riesenberg, USA, 1918

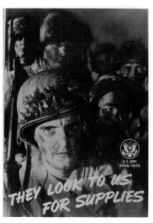

PAGE 67
Uncredited, USA, 1945

PAGE 69
Uncredited, USA, 1943

PAGE 71
Uncredited, USA, 1943

PAGE 73
Ermle, Germany, 1938
"Greater Germany:
Yes on 10 April."

PAGE 75
Collins, USA, 1942

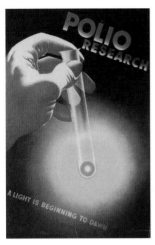

PAGE 77
Herbert Bayer, USA, 1949

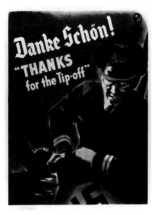

PAGE 79
Charles Taber, Canada, 1942

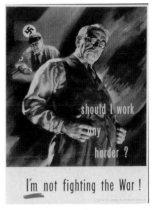

PAGE 81
Nick Hufford, USA, 1943

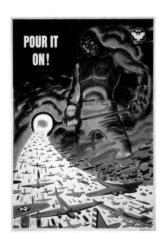

PAGE 83
Price W. Garrett, USA, 1942

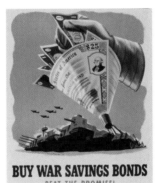

PAGE 85
Uncredited, USA, 1944

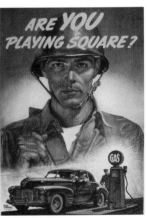

PAGE 87
Dean Cornwell, USA, 1942

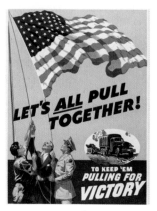

PAGE 89
Uncredited, USA, 1943

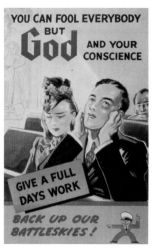

PAGE 91
Uncredited, USA, 1944

PAGE 93
George Roepp, USA, 1943

PAGE 95
J. Howard Miller, USA, 1943

PAGE 97
Jack Davis, USA, 1944

PAGE 99
Pat Keely, UK, 1943

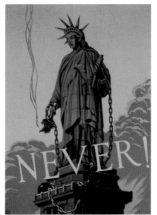

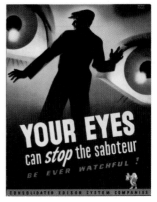

ACKNOWLEDGMENTS

I WOULD LIKE TO THANK the Office of War Information and all of the brilliant artists and writers who worked therein. The original versions of these posters were designed by the best admen Madison Avenue had to offer and were produced at a time when America was fighting a Fascist menace which threatened to cover the globe and strip us of our freedoms. Little could anyone have suspected that sixty years later, America would be the country which the world fears and despises and that our own government would be attempting to strip us of those same freedoms our grandpathers fought for. I dedicate this book to the memory of all artists who fought—and who are still fighting—dictatorship, fascism and tyranny.

Many thanks to the Library of Congress, the National Archives, Northwestern University, The Chisholm Gallery in NYC, The International Poster Gallery in Boston, and Miscman.com for making high-quality originals available for me to deface.

Many thanks to Greg Ruggiero, Jay Lender, and Jim Norton for helping me choose posters and edit the text. Any mistakes here exist because I ignored their advice.

Thanks to Dan Simon for recognizing that we're all human and we all make mistakes, some of us bigger mistakes than others. Thanks to Richard Leiby for helping me see the way out of my hole.

Thank you, Dear Reader, for buying this book. I hereby invite you to break the spine and photocopy these posters onto larger sized pieces of paper, and then glue them all over your school, neighborhood, protest placards, SUV windows, telephone poles, trash cans or any other convenient place where they might be seen and hopefully change some minds. My only request is that you email me a photo of your postering efforts.

Finally, many thanks to Alissa Rowinsky, who has a copywriter's eye, an editor's drive, a writer's touch, and a giant heart. She was the anchor which kept me sane through the sickening (both in amount and subject matter) research on this book. She put up with loud screams of "I hate writing about this bunch of evil scumbags" at irregular hours, impatient demands, writer's block, three weeks of odd sleep patterns and the sullen nature which accompanied them. I love her and I worship her for loving me back.

ABOUT THE AUTHORS

MICAH IAN WRIGHT is a writer who has worked in television, comic books, graphic novels, videogames, and film. After seeing a new series of National Security Administration posters in 2001 that used obvious fascist imagery to sell the war in Afghanistan, Micah was inspired to begin remixing old propaganda to point out the hypocrisy of modern American politics. He has completed over 500 posters, which can be seen at www.antiwarposters.com. His work has been featured in the *New York Times*, the *Washington Post* (twice!), *Sunday Guardian* (UK), the *Progressive*, the *Christian Science Monitor*, the *Boston Globe*, the *Nation*, the *Los Angeles Weekly*, *Mother Jones*, the *Village Voice*, *Adbusters Magazine*, and once, by accident, on the Fox News Channel (much to their chagrin).

J. R. NORTON is a producer for *The Al Franken Show* and the author of *Saving General Washington: The Right-Wing Assault on America's Founding Principles* (Tarcher/Penguin).